How to Draw Japanese Manga

# MANGA
# TECHNIQUES

## Vol.5

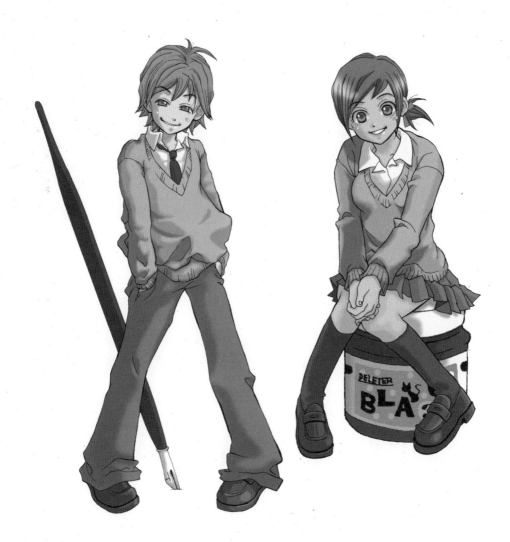

**An Instruction Manual for Manga Artists Around the World**

MANGA TECHNIQUES Vol. 5
How to Draw Japanese Manga
Copyright © 2003 S.E.Inc

First published in 2003 by S.E.Inc.
1-20-60 Miyauchi, Nakahara-ku, Kawasaki City 211-0051, Japan

Editing:Shunji Haraguchi
Composition and Illustrations: Kai Hinomoto

Distributor
Japan Publications Trading Co.,Ltd.
1-2-1 Sarugaku-cho, Chiyoda-ku,Tokyo 101-0064,Japan
E-mail:jpt@jptco.co.jp
URL:http://www.jptco.co.jp/

First printing: June 2003

ISBN  4-88996-134-8
Printed in Japan

# CONTENTS

## Chapter 1

**Drawing Techniques and Process**    **07**

## Chapter 2

**Tool Selection and Use**    **11**

| | |
|---|---|
| Paper | 12 |
| Pen tips | 14 |
| China Ink (Bokuju) | 18 |
| White | 21 |
| Pencil | 23 |
| Eraser | 25 |
| Rotring | 26 |
| Marker&Drawing Pen | 28 |
| Ruler | 30 |
| Tone | 33 |
| Tone Works | 36 |
| Water Dish | 43 |
| Tape | 43 |
| Light Box | 44 |

## Chapter 3

**How to Draw Different Characters**    **47**

## Chapter 4

**Background and Perspective**    **57**

## Chapter 5

**Drawing in Panels**    **65**

# CONTENTS

**07** Drawing Techniques and Process

**11** Tool Selection and Use

**47** How to Draw Different Characters

**57** Background and Perspective

**65** Drawing in Panels

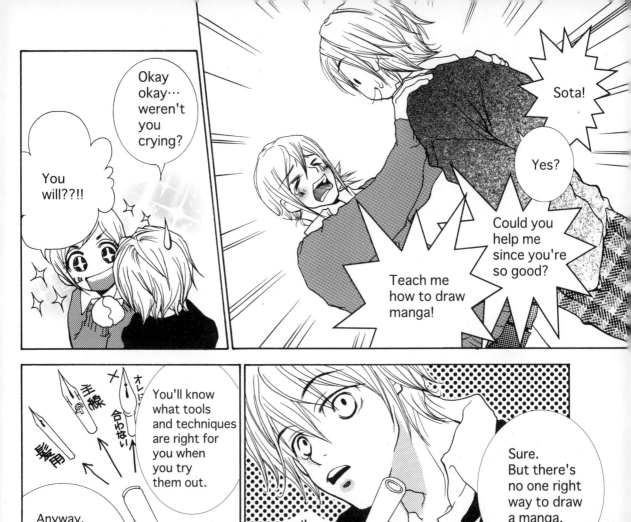

Okay okay··· weren't you crying?

You will??!!

Sota!

Yes?

Could you help me since you're so good?

Teach me how to draw manga!

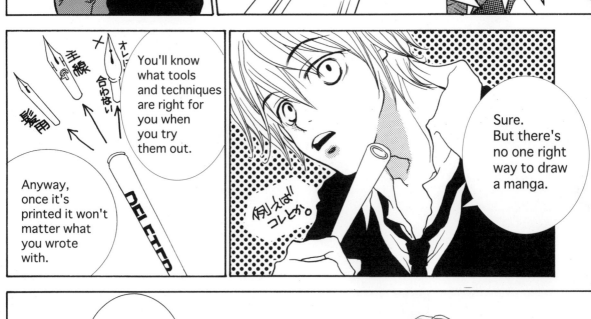

You'll know what tools and techniques are right for you when you try them out.

Anyway, once it's printed it won't matter what you wrote with.

Sure. But there's no one right way to draw a manga.

I've got it!

yeah...

I'll review everything while I teach it to you!

But I guess that doesn't help a beginner like you.

I bet you don't even know where to start.

So you're basically saying you don't really know either?

Huh?

# Chapter 1

# Drawing Techniques and Process

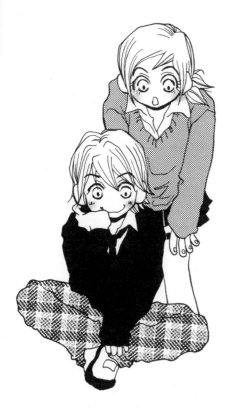

# Go!

❶ **Sketching**

❷ **Inking**

Usually draw the characters first, then add the background, effects, and other details.
*Wipe the ink off the pen with kleenex. After drawing, wash the tip of the pen in water right away and then dry it off.
If you leave ink on the pen, you'll ruin it.

❸ **Erasing**

First off, the procedure for drawing a manga usually flows like this.

**❻ Tone**

Use a cleaning brush or a design brush to wipe away the eraser bits.If there are any eraser particles left over, it will cause problems when you apply tones!Be careful! Any dirt or gunk caught under the tone will come out in the print!

**❹ Beta** (fill in the black)

**❺ White**

Erasing weakens the ink, so make sure you erase before you fill in the black areas.

Of course everybody does this process differently.

You should find the way that suits you best!

What's wrong?

I don't know…

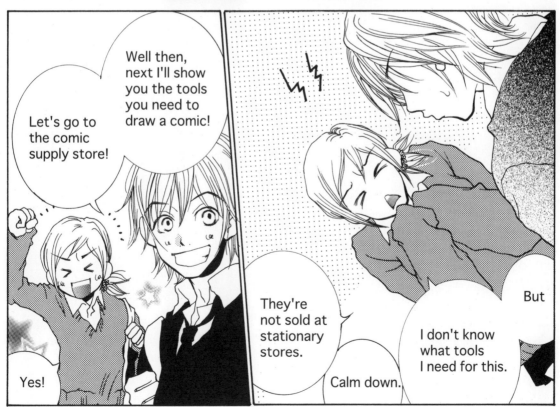

Well then, next I'll show you the tools you need to draw a comic!

Let's go to the comic supply store!

Yes!

They're not sold at stationary stores.

Calm down.

I don't know what tools I need for this.

But

# Chapter 2

## Tool Selection and Use

First off, paper.

What kind of paper should I use?

Definitely Kent paper!! Everybody knows it's the best!

Nothing is better than big, thick paper.

ケント

There are so many different types! I don't know..!

But the quality, thickness, and size vary…

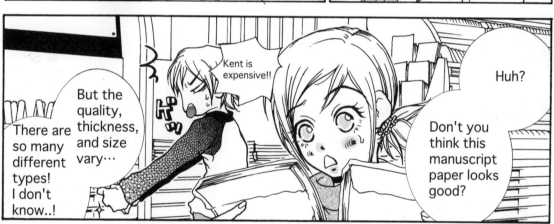

Kent is expensive!!

Huh?

Don't you think this manuscript paper looks good?

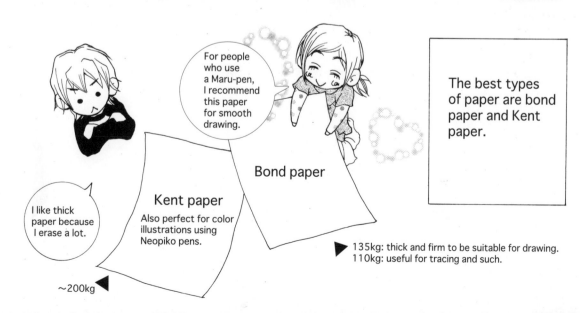

I like thick paper because I erase a lot.

For people who use a Maru-pen, I recommend this paper for smooth drawing.

Kent paper
Also perfect for color illustrations using Neopiko pens.

Bond paper

The best types of paper are bond paper and Kent paper.

▶ 135kg: thick and firm to be suitable for drawing.
110kg: useful for tracing and such.

~200kg ◀

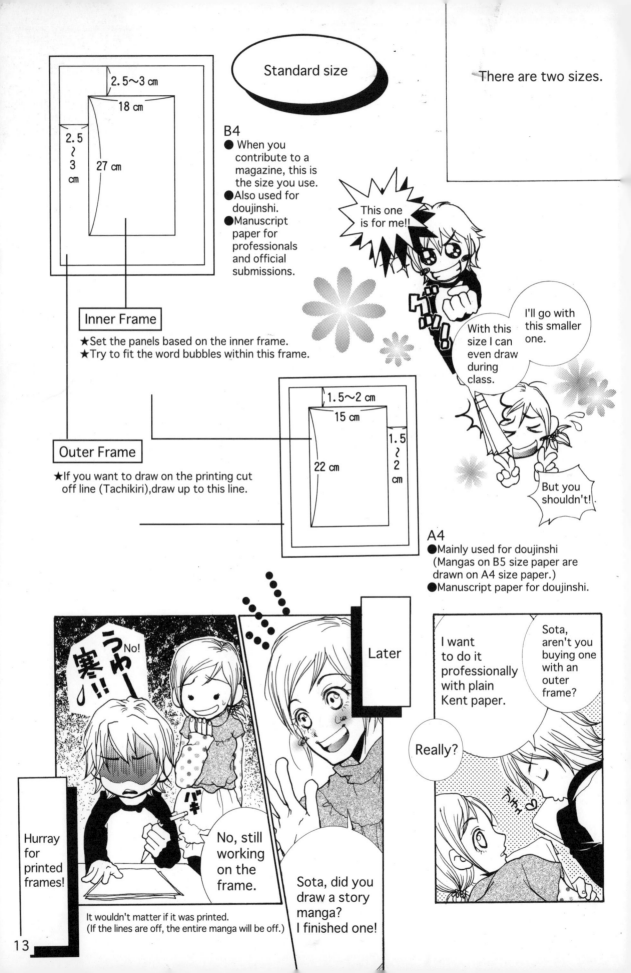

**Standard size**

There are two sizes.

**B4**
- When you contribute to a magazine, this is the size you use.
- Also used for doujinshi.
- Manuscript paper for professionals and official submissions.

2.5~3 cm
18 cm
2.5 ~ 3 cm
27 cm

This one is for me!!

With this size I can even draw during class.

I'll go with this smaller one.

But you shouldn't!

**Inner Frame**

★Set the panels based on the inner frame.
★Try to fit the word bubbles within this frame.

**Outer Frame**

★If you want to draw on the printing cut off line (Tachikiri), draw up to this line.

1.5~2 cm
15 cm
22 cm
1.5 ~ 2 cm

**A4**
- Mainly used for doujinshi (Mangas on B5 size paper are drawn on A4 size paper.)
- Manuscript paper for doujinshi.

No! うゎー寒!!

Later

I want to do it professionally with plain Kent paper.

Sota, aren't you buying one with an outer frame?

Really?

Hurray for printed frames!

No, still working on the frame.

It wouldn't matter if it was printed. (If the lines are off, the entire manga will be off.)

Sota, did you draw a story manga? I finished one!

# PEN TIPS

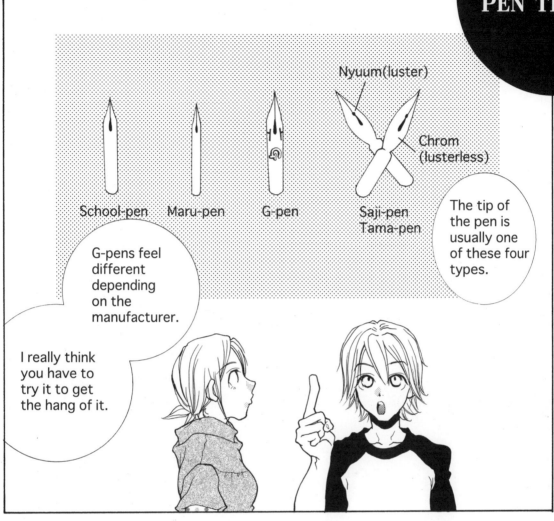

Nyuum(luster)

Chrom (lusterless)

School-pen  Maru-pen  G-pen  Saji-pen Tama-pen

The tip of the pen is usually one of these four types.

G-pens feel different depending on the manufacturer.

I really think you have to try it to get the hang of it.

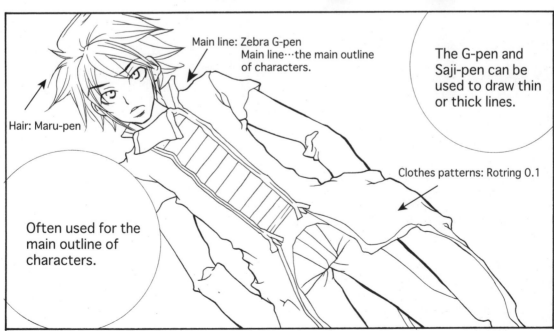

Main line: Zebra G-pen
Main line···the main outline of characters.

Hair: Maru-pen

The G-pen and Saji-pen can be used to draw thin or thick lines.

Clothes patterns: Rotring 0.1

Often used for the main outline of characters.

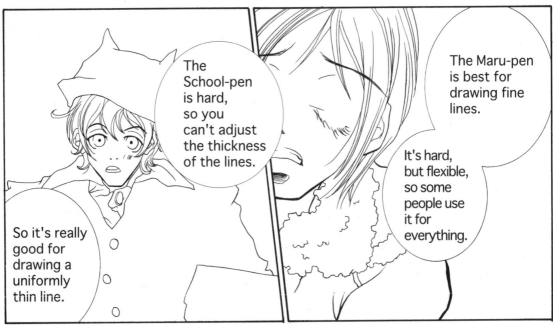

The School-pen is hard, so you can't adjust the thickness of the lines.

So it's really good for drawing a uniformly thin line.

The Maru-pen is best for drawing fine lines.

It's hard, but flexible, so some people use it for everything.

It's no use getting hung up on what kind of pen to use.

And others use the same one for everything.

Of course some people switch pen tips,

●For drawing the face: HI-TEC-C/0.3
●For outlines and clothes: Neopiko Line/0.05, 0.2, 0.8
●For hair: Brush pen (Pentel medium size brush pen)

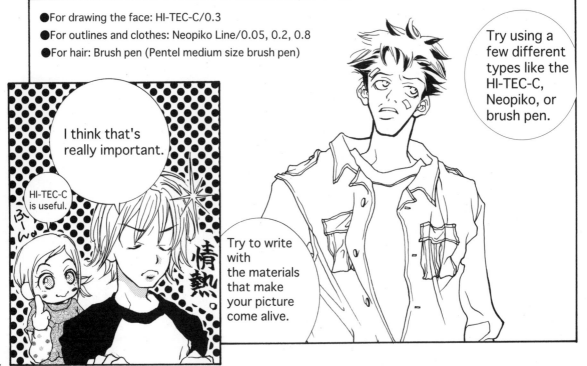

Try using a few different types like the HI-TEC-C, Neopiko, or brush pen.

I think that's really important.

HI-TEC-C is useful.

情熱

Try to write with the materials that make your picture come alive.

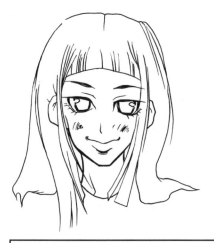

Saji-pen

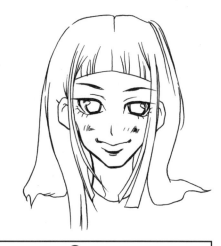

G-pen

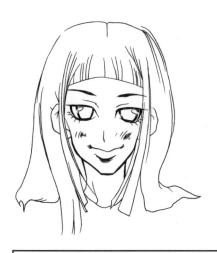

School-pen

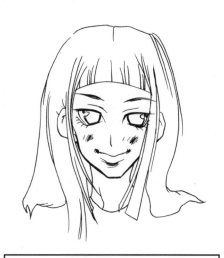

Maru-pen

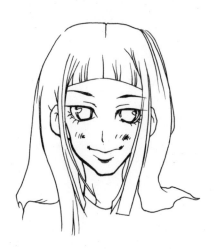

NEOPIKO Line

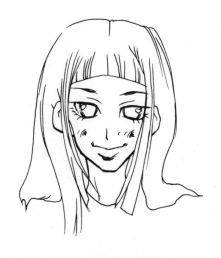

HI-TEC-C

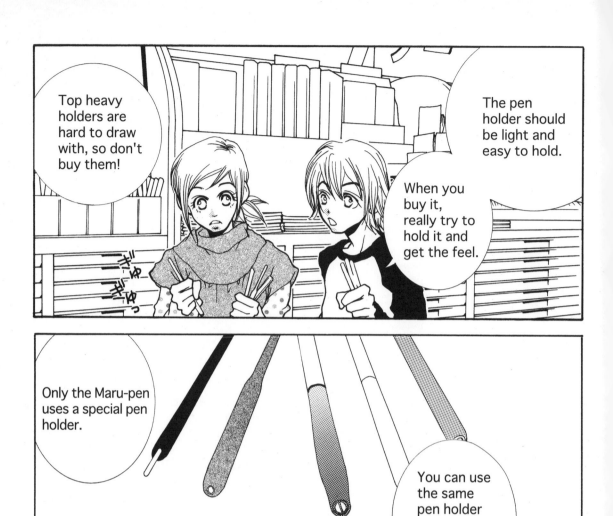

Top heavy holders are hard to draw with, so don't buy them!

The pen holder should be light and easy to hold.

When you buy it, really try to hold it and get the feel.

Only the Maru-pen uses a special pen holder.

You can use the same pen holder with a G-pen, Tama pen, or a Saji-pen.

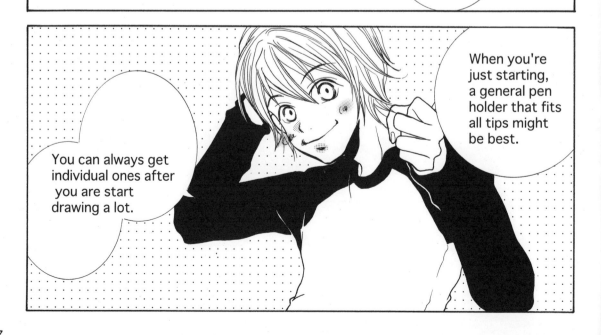

When you're just starting, a general pen holder that fits all tips might be best.

You can always get individual ones after you are start drawing a lot.

Magazine submission guidelines say, "Don't use weak ink or a felt pen"

You have to draw your comic in black so that it can be printed!

because if the ink is weak, it won't print well.

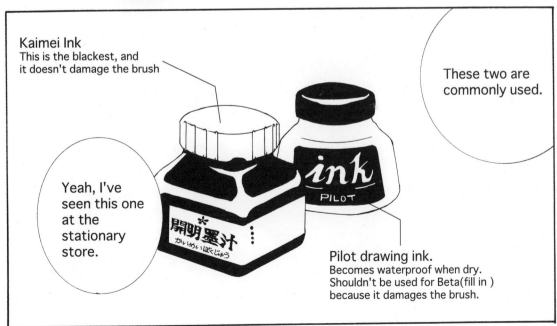

Kaimei Ink
This is the blackest, and it doesn't damage the brush

These two are commonly used.

Yeah, I've seen this one at the stationary store.

開明墨汁
かいめいぼくじゅう

ink
PILOT

Pilot drawing ink.
Becomes waterproof when dry. Shouldn't be used for Beta(fill in ) because it damages the brush.

18

I really sweat a lot…

And it really blurs the ink when I'm drawing.

Yeah! I have that problem, too!

Uhm, by the way …

Yes?

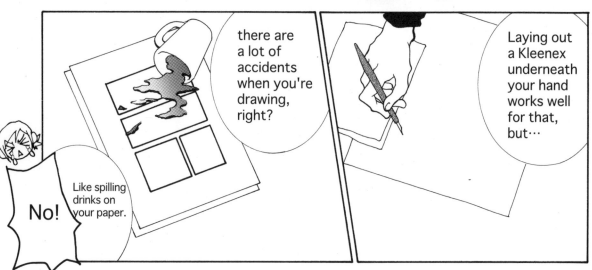

there are a lot of accidents when you're drawing, right?

No!

Like spilling drinks on your paper.

Laying out a Kleenex underneath your hand works well for that, but…

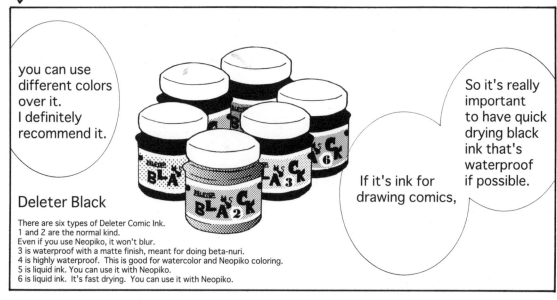

you can use different colors over it. I definitely recommend it.

So it's really important to have quick drying black ink that's waterproof if possible.

If it's ink for drawing comics,

### Deleter Black

There are six types of Deleter Comic Ink.
1 and 2 are the normal kind.
Even if you use Neopiko, it won't blur.
3 is waterproof with a matte finish, meant for doing beta-nuri.
4 is highly waterproof. This is good for watercolor and Neopiko coloring.
5 is liquid ink. You can use it with Neopiko.
6 is liquid ink. It's fast drying. You can use it with Neopiko.

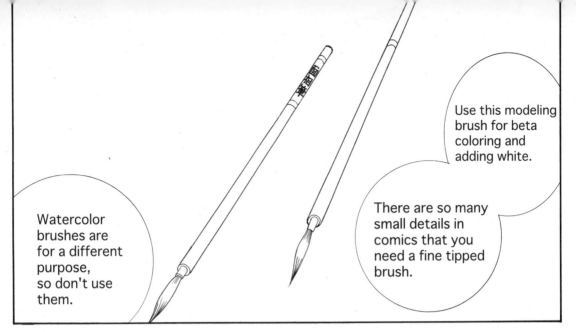

Watercolor brushes are for a different purpose, so don't use them.

Use this modeling brush for beta coloring and adding white.

There are so many small details in comics that you need a fine tipped brush.

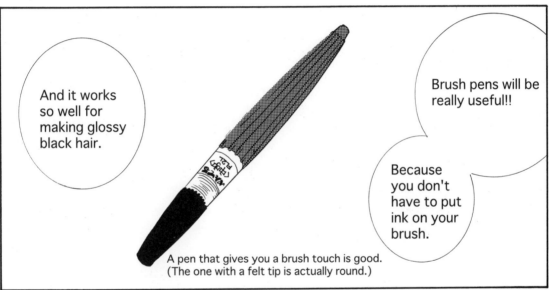

And it works so well for making glossy black hair.

Brush pens will be really useful!!

Because you don't have to put ink on your brush.

A pen that gives you a brush touch is good.
(The one with a felt tip is actually round.)

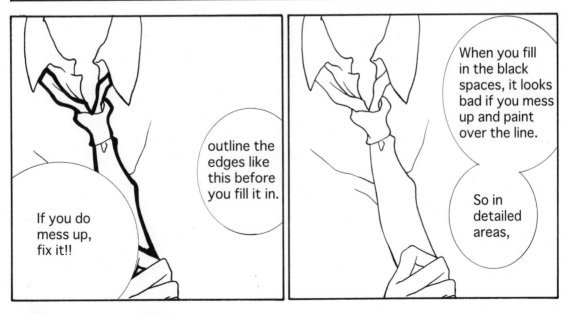

outline the edges like this before you fill it in.

If you do mess up, fix it!!

When you fill in the black spaces, it looks bad if you mess up and paint over the line.

So in detailed areas,

White to make stars.

White for hair.

To put the twinkle in eyes.

You do all that?

Definitely!

One of these pretty much does it for me.

DELETER WHITE

Dr.Martin's BLEED PROOF WHITE

Dr.Martin's PEN-WHITE

To apply white to details,

you need these kinds in addition to normal whiteout.

You can use it like that as white ink!

Shake well!

Pen-White is so useful!

You put it directly on to the tip of the pen with an eye-dropper.

Do it with a different pen tip!

It's probably a good idea to prepare a separate pen holder and tip for Pen-White.

You can use a ruler to make effect lines!

21

Concentration lines over Beta.

Right. I used it to write letters on black paper.

Well, they're really useful.

And then there's the Milky Pen, or white ball-point pen.

You have one of those, don't you?

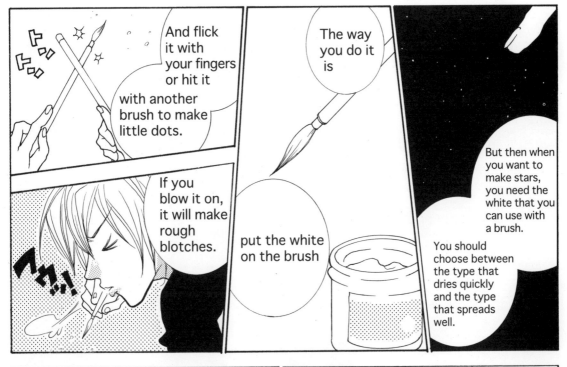

And flick it with your fingers or hit it with another brush to make little dots.

If you blow it on, it will make rough blotches.

The way you do it is

put the white on the brush

But then when you want to make stars, you need the white that you can use with a brush.

You should choose between the type that dries quickly and the type that spreads well.

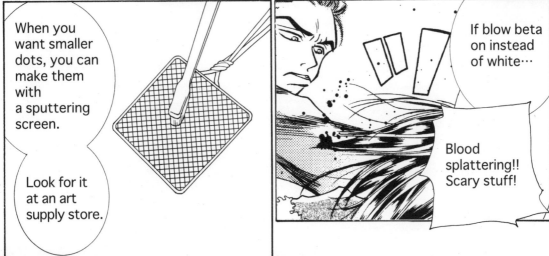

When you want smaller dots, you can make them with a sputtering screen.

Look for it at an art supply store.

If blow beta on instead of white…

Blood splattering!! Scary stuff!

22

# PENCIL

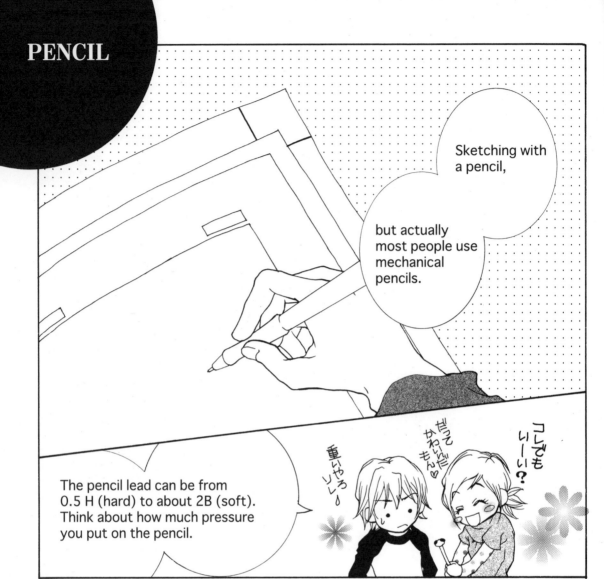

Sketching with a pencil,

but actually most people use mechanical pencils.

The pencil lead can be from 0.5 H (hard) to about 2B (soft). Think about how much pressure you put on the pencil.

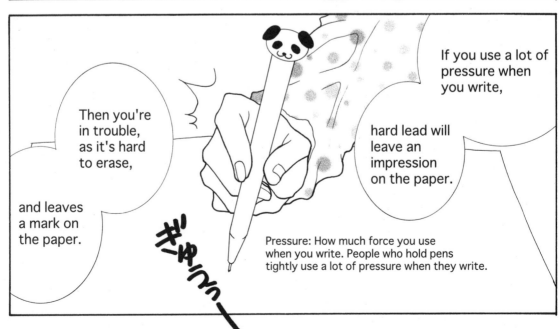

If you use a lot of pressure when you write,

hard lead will leave an impression on the paper.

Then you're in trouble, as it's hard to erase,

and leaves a mark on the paper.

Pressure: How much force you use when you write. People who hold pens tightly use a lot of pressure when they write.

As for me,

That's so smart!

Light blue and yellow don't come out in the printing so you don't even need to erase them!

I sketch with a light blue pencil.

OH!!

Exactly.

But remember that it could come out if you apply tones.

You sometimes see things like this, right?

That would be bad...

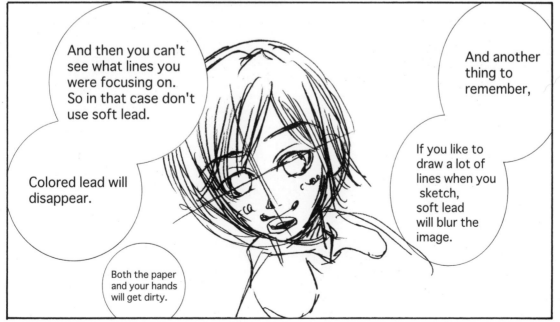

And then you can't see what lines you were focusing on. So in that case don't use soft lead.

And another thing to remember,

If you like to draw a lot of lines when you sketch, soft lead will blur the image.

Colored lead will disappear.

Both the paper and your hands will get dirty.

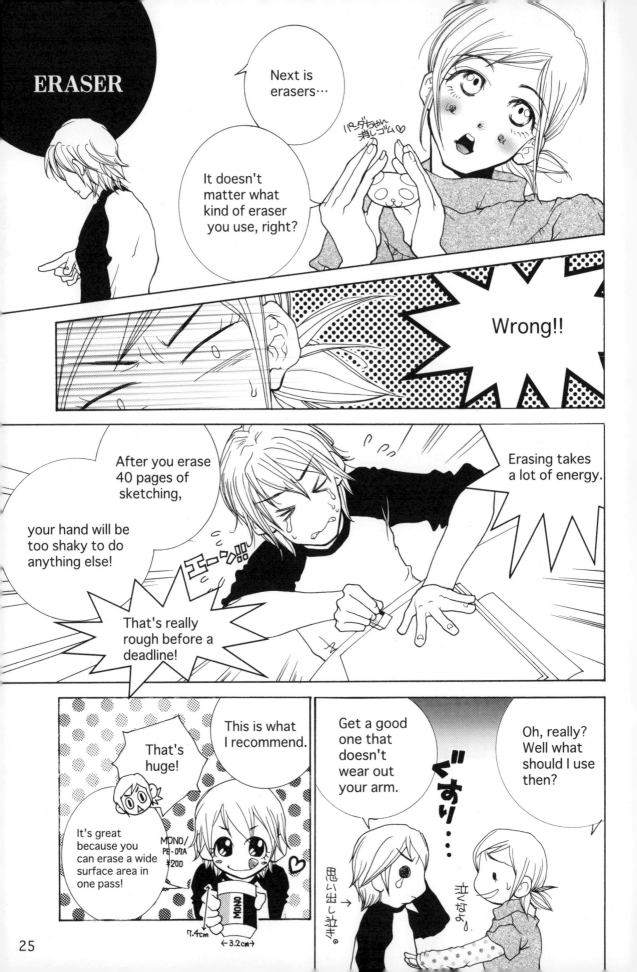

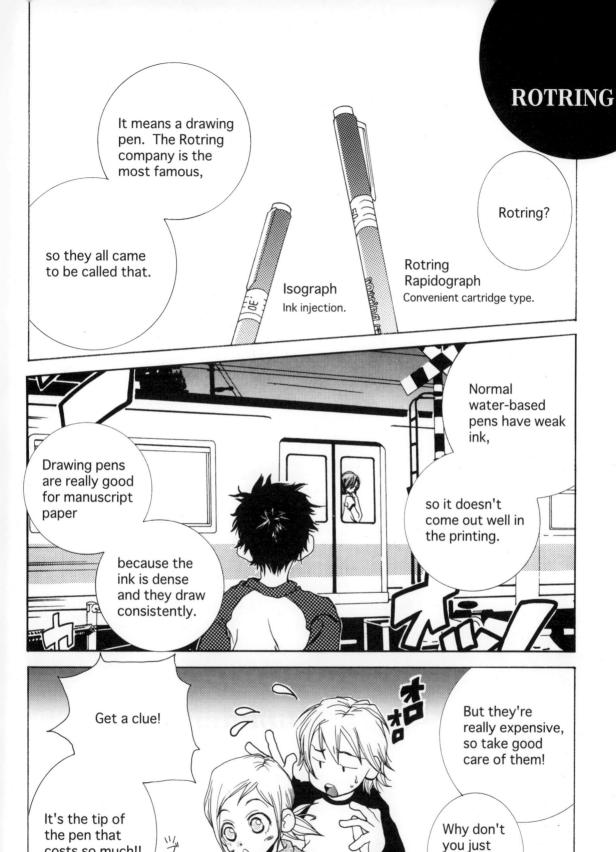

**ROTRING**

It means a drawing pen. The Rotring company is the most famous,

so they all came to be called that.

Rotring?

Isograph
Ink injection.

Rotring Rapidograph
Convenient cartridge type.

Normal water-based pens have weak ink,

so it doesn't come out well in the printing.

Drawing pens are really good for manuscript paper

because the ink is dense and they draw consistently.

Get a clue!

But they're really expensive, so take good care of them!

It's the tip of the pen that costs so much!!

Why don't you just change the pen tip?

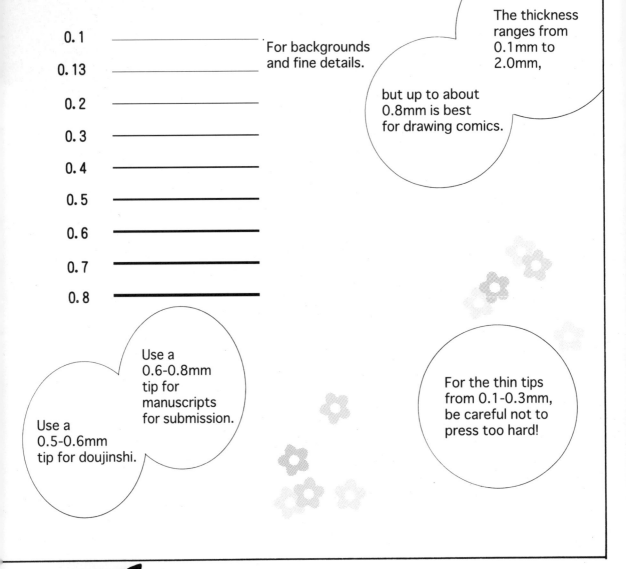

0.1 — For backgrounds and fine details.

0.13

0.2

0.3

0.4

0.5

0.6

0.7

0.8

The thickness ranges from 0.1mm to 2.0mm,

but up to about 0.8mm is best for drawing comics.

Use a 0.6-0.8mm tip for manuscripts for submission.

Use a 0.5-0.6mm tip for doujinshi.

For the thin tips from 0.1-0.3mm, be careful not to press too hard!

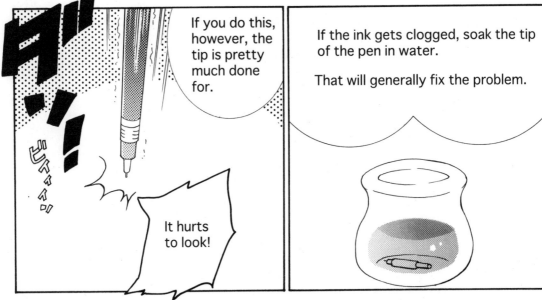

If you do this, however, the tip is pretty much done for.

It hurts to look!

If the ink gets clogged, soak the tip of the pen in water.

That will generally fix the problem.

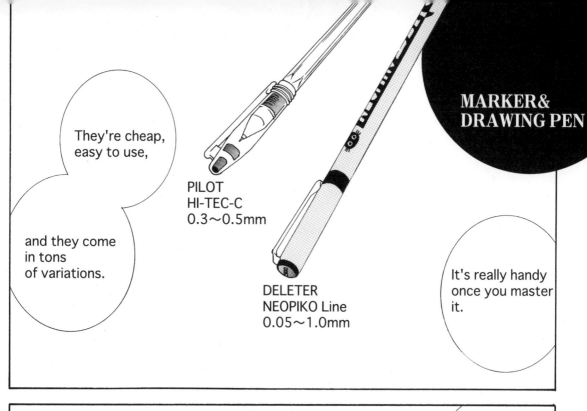

# MARKER & DRAWING PEN

They're cheap, easy to use,

and they come in tons of variations.

PILOT
HI-TEC-C
0.3～0.5mm

DELETER
NEOPIKO Line
0.05～1.0mm

It's really handy once you master it.

If the ink is too weak, the lines won't be clear when you print,

and it will look really bad!

Anyway, you should get thick ink.

When you erase,

the fine lines get weaker, and it looks unclear.
So be careful!!

A 0.1mm drawing pen and a Maru-pen are the same way.

Also, oil-based pens aren't good for something you want to last for a long time.

Oil-based pens definitely come out well in print.

SAKURA
MY NAME/Fine

But the line blurs?

Well...

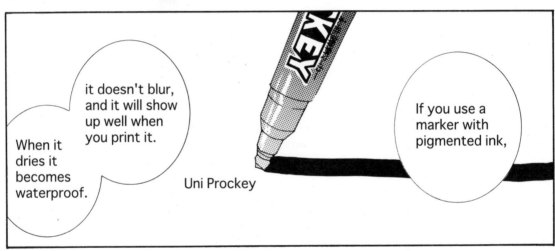

it doesn't blur, and it will show up well when you print it.

When it dries it becomes waterproof.

Uni Prockey

If you use a marker with pigmented ink,

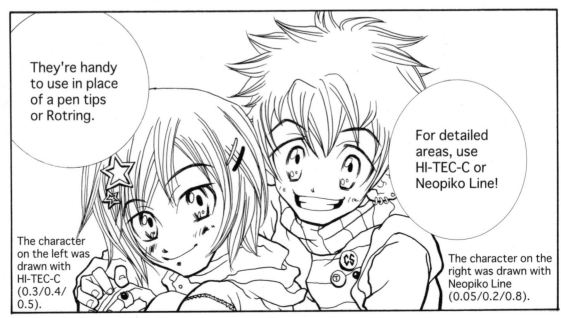

They're handy to use in place of a pen tips or Rotring.

For detailed areas, use HI-TEC-C or Neopiko Line!

The character on the left was drawn with HI-TEC-C (0.3/0.4/0.5).

The character on the right was drawn with Neopiko Line (0.05/0.2/0.8).

# RULER

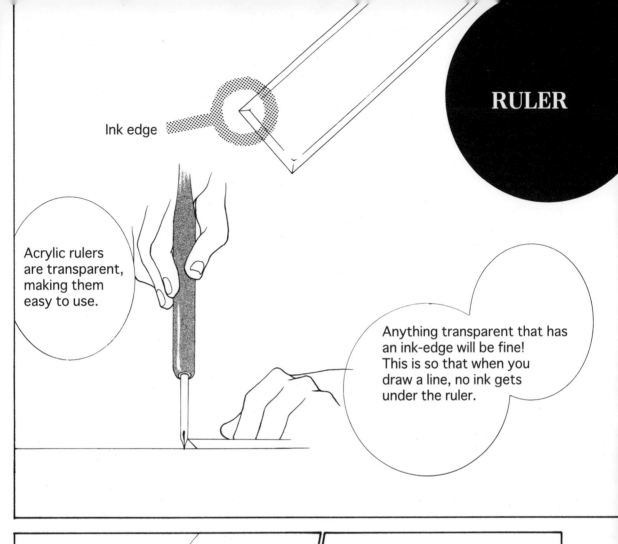

Ink edge

Acrylic rulers are transparent, making them easy to use.

Anything transparent that has an ink-edge will be fine! This is so that when you draw a line, no ink gets under the ruler.

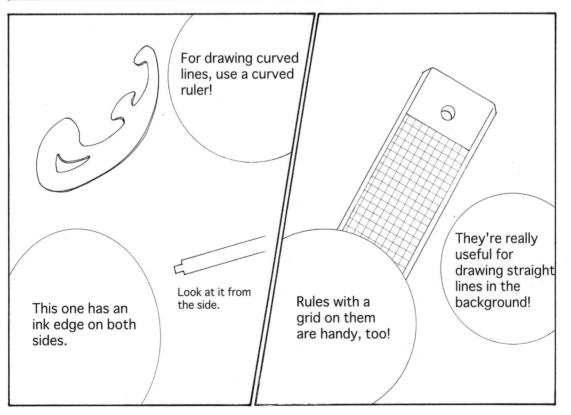

For drawing curved lines, use a curved ruler!

This one has an ink edge on both sides.

Look at it from the side.

Rules with a grid on them are handy, too!

They're really useful for drawing straight lines in the background!

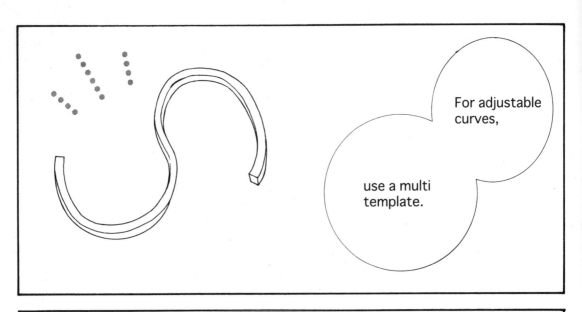

For adjustable curves,

use a multi template.

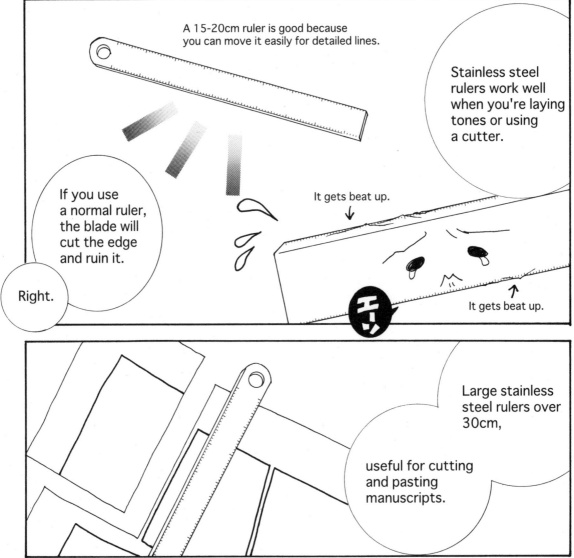

A 15-20cm ruler is good because you can move it easily for detailed lines.

Stainless steel rulers work well when you're laying tones or using a cutter.

If you use a normal ruler, the blade will cut the edge and ruin it.

Right.

It gets beat up.

It gets beat up.

Large stainless steel rulers over 30cm,

useful for cutting and pasting manuscripts.

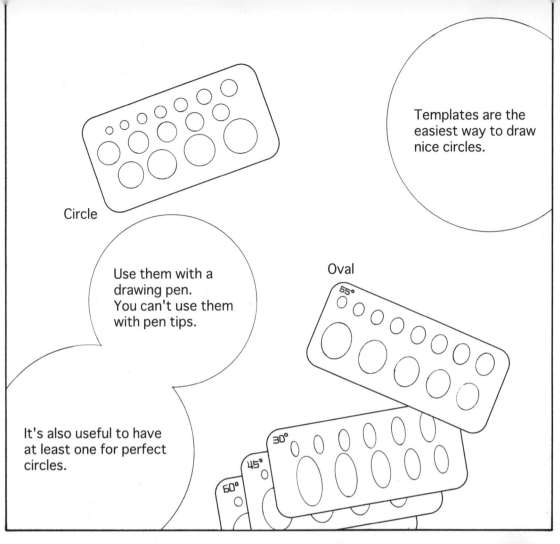

Templates are the easiest way to draw nice circles.

Circle

Use them with a drawing pen.
You can't use them with pen tips.

Oval

It's also useful to have at least one for perfect circles.

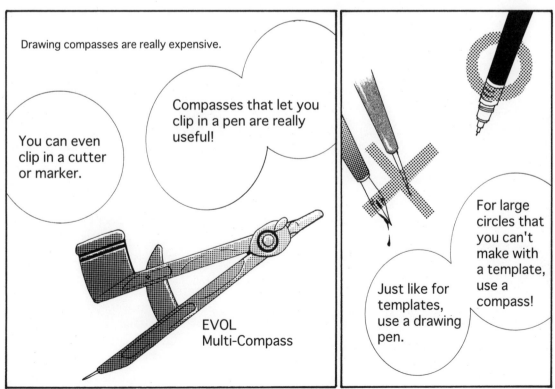

Drawing compasses are really expensive.

Compasses that let you clip in a pen are really useful!

You can even clip in a cutter or marker.

EVOL Multi-Compass

Just like for templates, use a drawing pen.

For large circles that you can't make with a template, use a compass!

# TONE

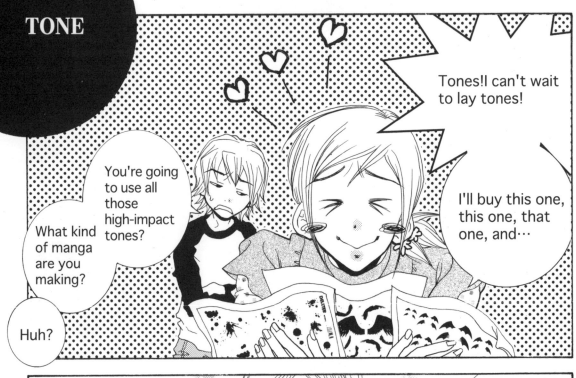

Tones! I can't wait to lay tones!

You're going to use all those high-impact tones?

What kind of manga are you making?

I'll buy this one, this one, that one, and…

Huh?

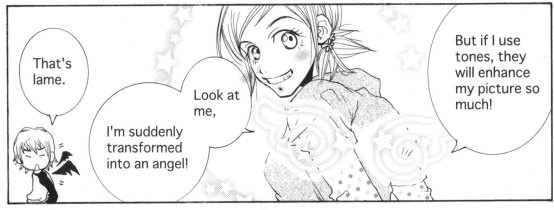

That's lame.

Look at me,

I'm suddenly transformed into an angel!

But if I use tones, they will enhance my picture so much!

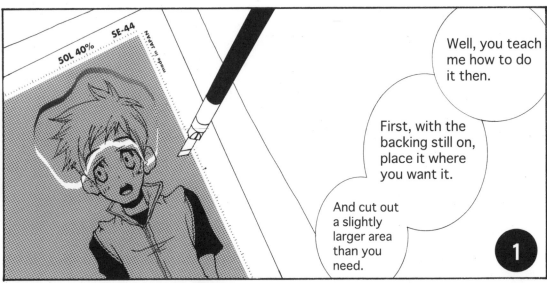

Well, you teach me how to do it then.

First, with the backing still on, place it where you want it.

And cut out a slightly larger area than you need.

1

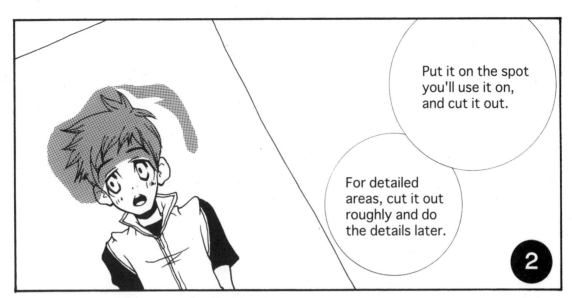

Put it on the spot you'll use it on, and cut it out.

For detailed areas, cut it out roughly and do the details later.

**2**

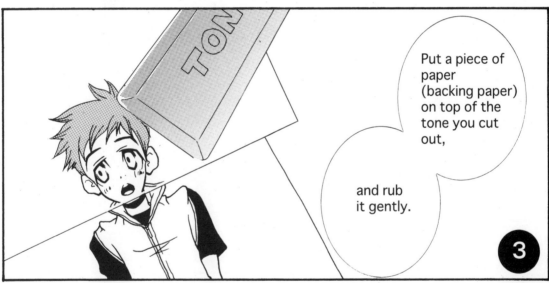

Put a piece of paper (backing paper) on top of the tone you cut out,

and rub it gently.

**3**

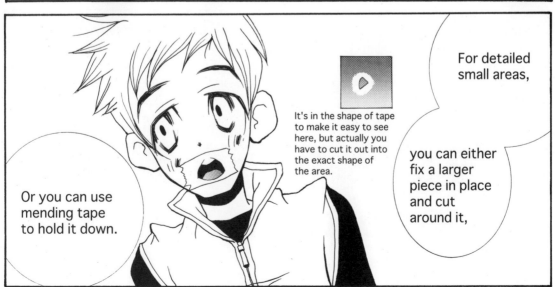

For detailed small areas,

It's in the shape of tape to make it easy to see here, but actually you have to cut it out into the exact shape of the area.

you can either fix a larger piece in place and cut around it,

Or you can use mending tape to hold it down.

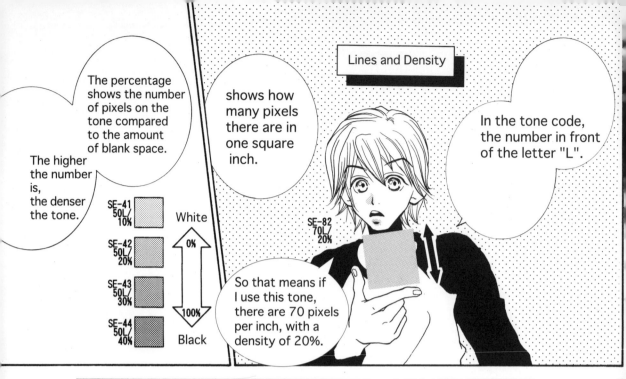

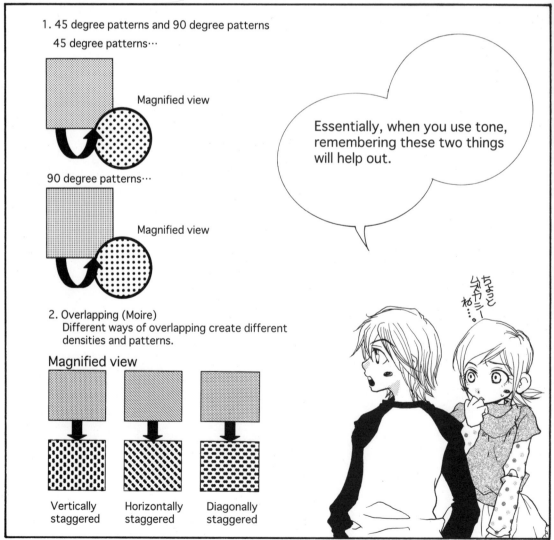

There are a lot of tones available, from basic patterns to nice features. Based on the way you use them, you can make various effects. Don't just apply them as they are, find new ways to utilize them.

## How to apply a shadow

When you apply a shadow, the most important thing is to think about where your light source is, and match the areas of shadow, otherwise it will make the picture look strange. Pay special attention to the light source if it a specific point, such as a lamp.

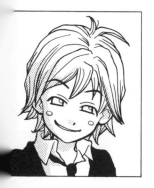 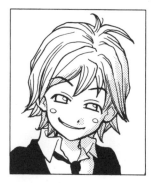 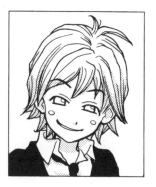 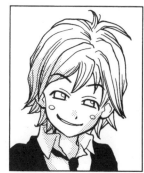

In the picture on the right, people are looking up at fireworks. You can express different degrees of light by using different tones that have different density, changing the impression of the picture.

Still dim lighting.

↓

A fireworks rocket is ascending.

↓

A bright explosion lights their faces. (backlight)

皆、
ありがとう♡

SE-895

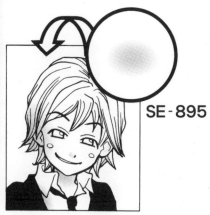

Not only simple screen tones, you can also use tones with gradation effects to make shadow.

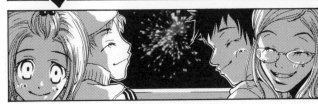

Tones used: First panel SE-41
Second panel SE-32
Third panel SE-53

# How to use tones effectively

1. Apply directly to express its shape.
2. Apply over a character to express a different effect.
3. Express a shape using gradation tone.
   Gradation tone in particular comes in different shades as you can see,
   so it makes it easy to express differences in shading and is great for just about everything.

## ●Trees

1. Express trees by applying directly.

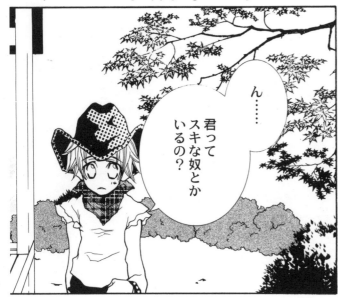

2. Apply a tone over a character to express the shadow of trees. Applying it this way creates the impression of trees on both sides of the panel.

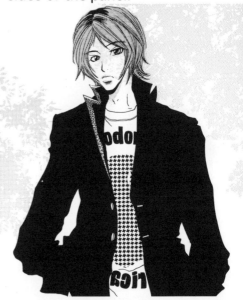

3. Use a gradation tone, and cut out the bright areas of the trees to express their shape.

# ●Sky

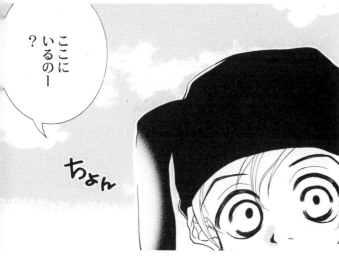

ここにいるのー？

ちょん

1.Use a sky tone.

2.To express a scene of
being lost in memories.

君が僕をスキなコトの意味を、僕は見つけたいー。

# ●Water

3.Trim a gradient tone to express
the appearance of flowing
or splashing water.

# ●Beta Flash

Use beta flash when (1) you want to express a character being surprised or (2) to add tension to words.

In example (3) however, it is being used to express that there is a light source in the back, which is backlighting the character and the car in the foreground.

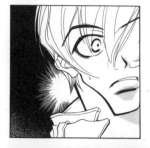 

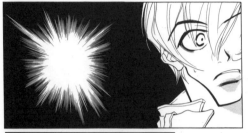 

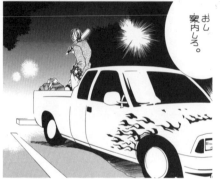 

# ●Pointillist Tone

(1)and (2)show effective use to express a feeling.
(3) is a sand tone, used to express the same texture as (2).

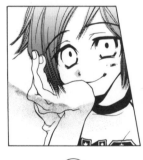 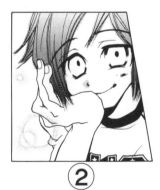

# ●Explosion

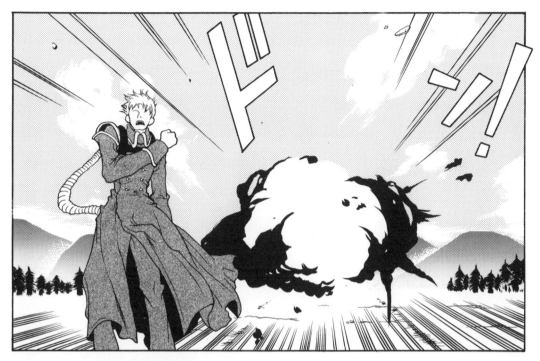

1.An explosion made with beta.

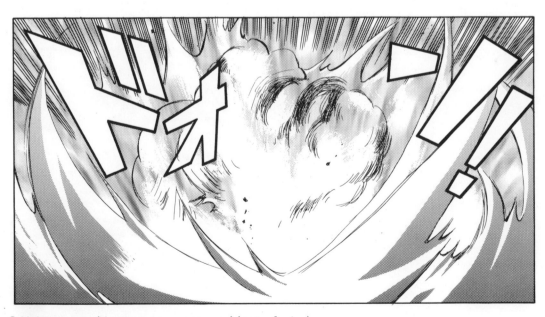

2.Using a graphic tone to express a blast of wind.
  Applying a gradient tone to the smoke rising up to show the lighting.

# ●Tips

With things like uniforms, if there's a wide area of beta, the whole picture seems heavy.
(On the other hand, if there's not much beta it gives a soft, light impression.)
In that case, take a gradient tone and apply it so that the light side is in the
direction of the light source.  This creates a three dimensional effect.
Try out crosshatch and sand gradation tones.

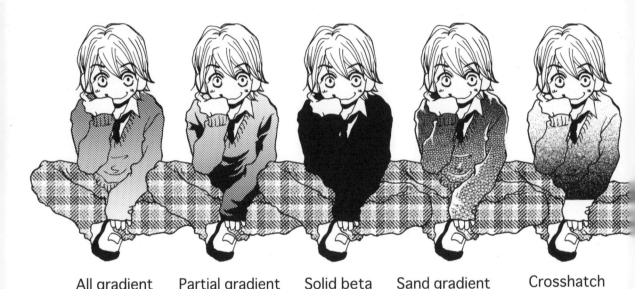

All gradient    Partial gradient    Solid beta    Sand gradient    Crosshatch

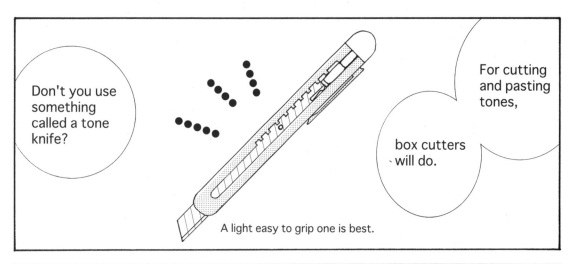

Don't you use something called a tone knife?

For cutting and pasting tones,

box cutters will do.

A light easy to grip one is best.

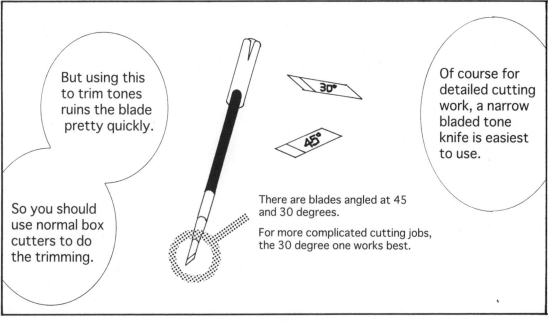

But using this to trim tones ruins the blade pretty quickly.

So you should use normal box cutters to do the trimming.

Of course for detailed cutting work, a narrow bladed tone knife is easiest to use.

30°

45°

There are blades angled at 45 and 30 degrees.

For more complicated cutting jobs, the 30 degree one works best.

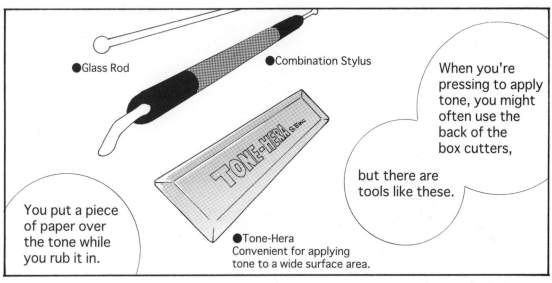

●Glass Rod

●Combination Stylus

When you're pressing to apply tone, you might often use the back of the box cutters,

but there are tools like these.

You put a piece of paper over the tone while you rub it in.

TONE-HERA S.Erc

●Tone-Hera
Convenient for applying tone to a wide surface area.

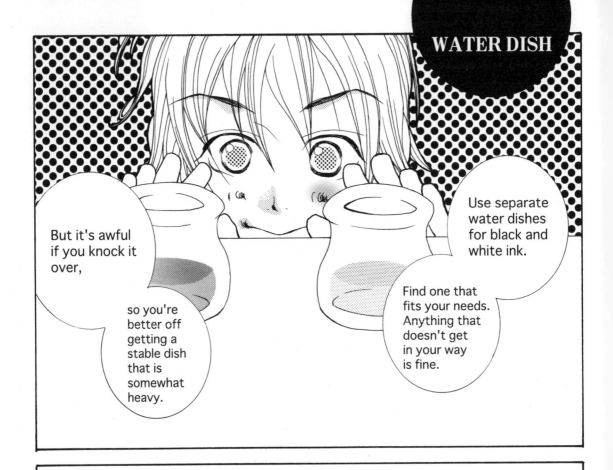

**WATER DISH**

But it's awful if you knock it over,

so you're better off getting a stable dish that is somewhat heavy.

Use separate water dishes for black and white ink.

Find one that fits your needs. Anything that doesn't get in your way is fine.

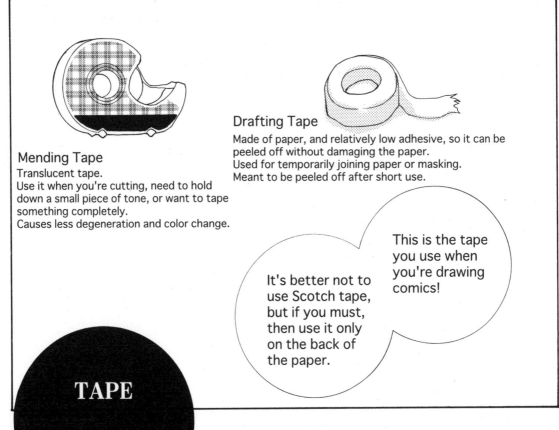

## Mending Tape
Translucent tape.
Use it when you're cutting, need to hold down a small piece of tone, or want to tape something completely.
Causes less degeneration and color change.

## Drafting Tape
Made of paper, and relatively low adhesive, so it can be peeled off without damaging the paper.
Used for temporarily joining paper or masking.
Meant to be peeled off after short use.

This is the tape you use when you're drawing comics!

It's better not to use Scotch tape, but if you must, then use it only on the back of the paper.

**TAPE**

# LIGHT BOX

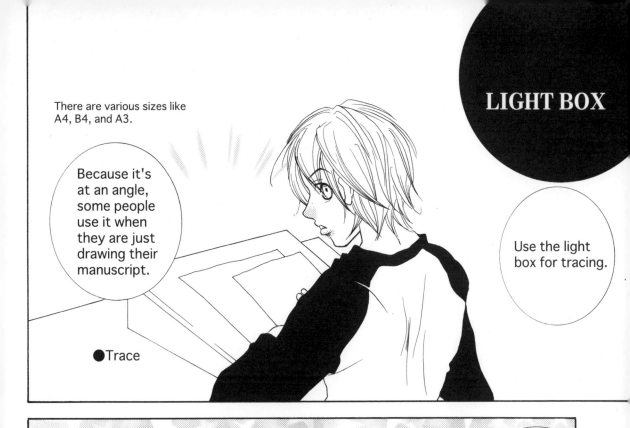

There are various sizes like A4, B4, and A3.

Because it's at an angle, some people use it when they are just drawing their manuscript.

Use the light box for tracing.

●Trace

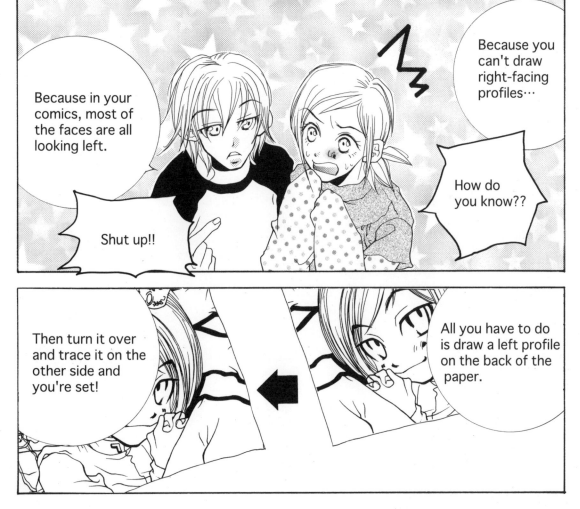

Because in your comics, most of the faces are all looking left.

Because you can't draw right-facing profiles…

Shut up!!

How do you know??

Then turn it over and trace it on the other side and you're set!

All you have to do is draw a left profile on the back of the paper.

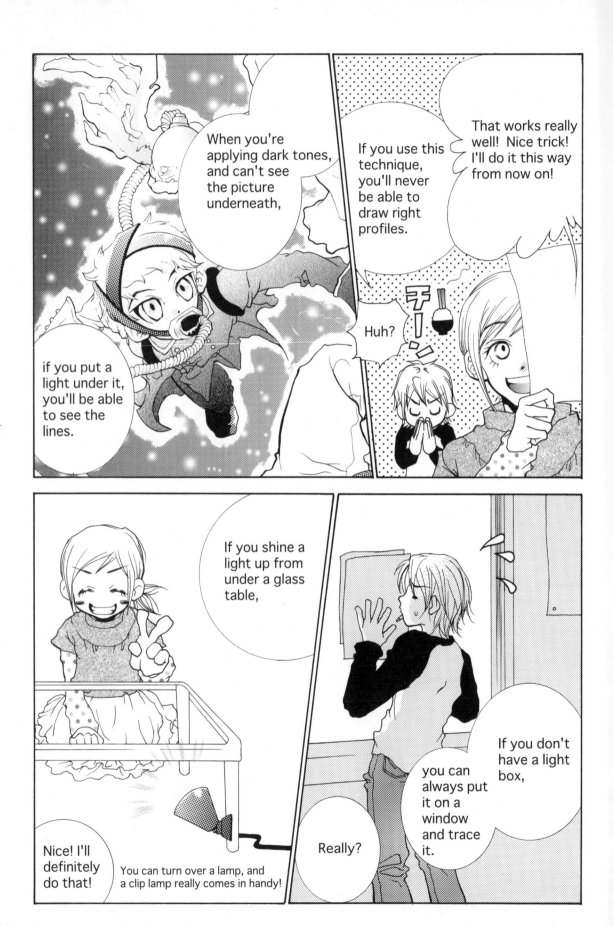

When you're applying dark tones, and can't see the picture underneath,

If you use this technique, you'll never be able to draw right profiles.

That works really well! Nice trick! I'll do it this way from now on!

Huh?

if you put a light under it, you'll be able to see the lines.

If you shine a light up from under a glass table,

Nice! I'll definitely do that!

You can turn over a lamp, and a clip lamp really comes in handy!

Really?

you can always put it on a window and trace it.

If you don't have a light box,

Just like you, beginners don't even know where to buy the right tools.

You can get them from:
1. an art supply store.
2. a store with a comic supply section.
3. mail order.

I was that way too.

It's best to just go directly to the art supply store,

or art section.

Then you can look at the actual items and check them out.

If you want a nice, easy way to get them, then mail order!

「DELETER」will let you mail order, so check it out!

http://www.deleter.com/

make sure you know the exact model and manufacturer,

or they won't accept your order.

When you place an order at a store,

# Chapter 3

# How to Draw Different Characters

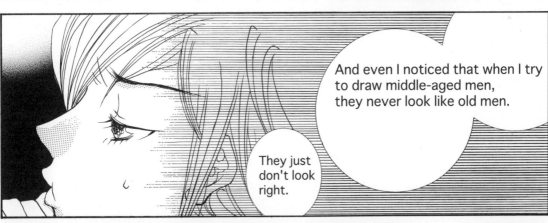

The shape and thickness of the eyebrows

The distance between the eye and eyebrow

The shape of the eye

Nose
(Smaller noses are cute.)

Size of the mouth

First of all, hairstyle!

Even if the face is the same, characters look completely different depending on the hairstyle.

The facial balance also changes the way they look.

Right.

A. Beta

Among those, I think the shape of the eyes change appearance the most.

They can be normal, slanted upward, slanted downward, sanpaku eyes, and eyes with large pupils.

B. White

C. Short hair

★To show older characters, decrease the size of the eyes.

Just the size of the eyes makes them look really different.

D. Tone

49

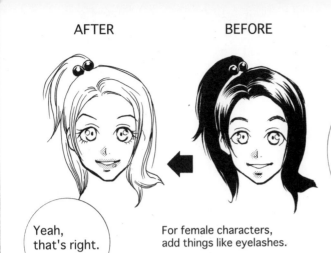

AFTER          BEFORE

Girls look different depending on the makeup.

The thickness of their eyebrows, eyelashes, and lips all change their appearance.

Yeah, that's right.

For female characters, add things like eyelashes.

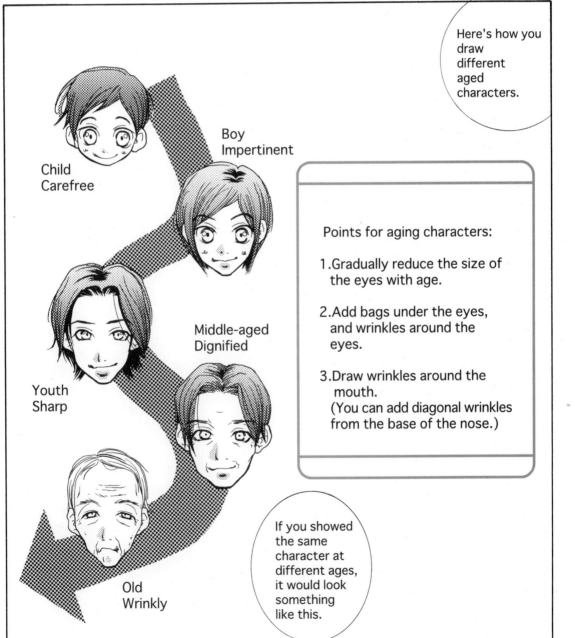

Here's how you draw different aged characters.

Child
Carefree

Boy
Impertinent

Youth
Sharp

Middle-aged
Dignified

Points for aging characters:

1. Gradually reduce the size of the eyes with age.

2. Add bags under the eyes, and wrinkles around the eyes.

3. Draw wrinkles around the mouth.
   (You can add diagonal wrinkles from the base of the nose.)

Old
Wrinkly

If you showed the same character at different ages, it would look something like this.

Let's see,

do you know the layout of the face?

Okay, so…

Of course I do!!

Facing to the side

Straight ahead

Facing downward

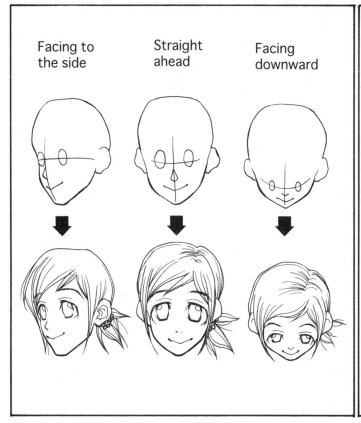

Drawing

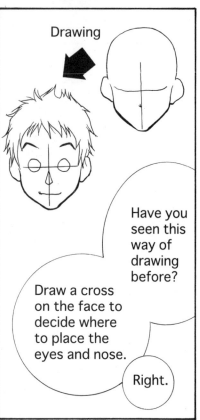

Have you seen this way of drawing before?

Draw a cross on the face to decide where to place the eyes and nose.

Right.

This is a useful point to remember for differentiating faces.

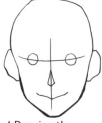

★Drawing the eyes and nose in the lower portion of a large face make it look younger, while place the eyes higher make it look like an adult.

The position of the eyes and the nose can make a face look older or younger.

Ah! It really does!

Some people are just good at drawing one or the other.

Like me?

What about the difference between men and women?

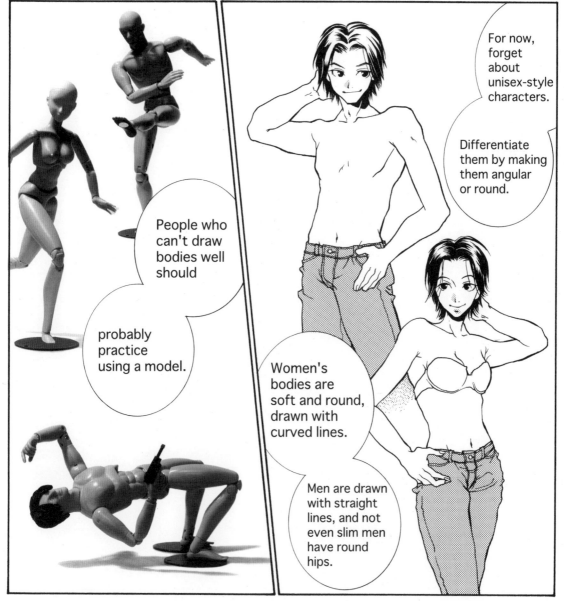

People who can't draw bodies well should

probably practice using a model.

For now, forget about unisex-style characters.

Differentiate them by making them angular or round.

Women's bodies are soft and round, drawn with curved lines.

Men are drawn with straight lines, and not even slim men have round hips.

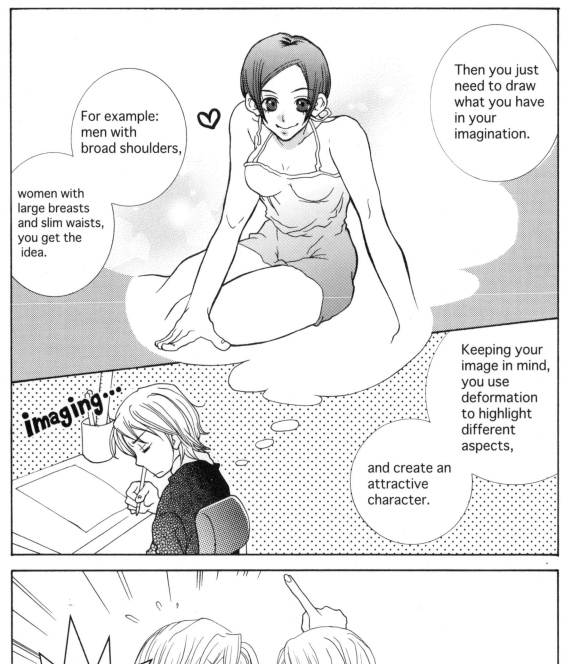

Then you just need to draw what you have in your imagination.

For example: men with broad shoulders,

women with large breasts and slim waists, you get the idea.

imaging...

Keeping your image in mind, you use deformation to highlight different aspects,

and create an attractive character.

It's no joking matter!

Imagination... don't you mean fantasy?

So you can't really draw bodies…

Ohhhhhhh…

Speaking of the shape of the body, aren't all your pictures close-ups of faces?

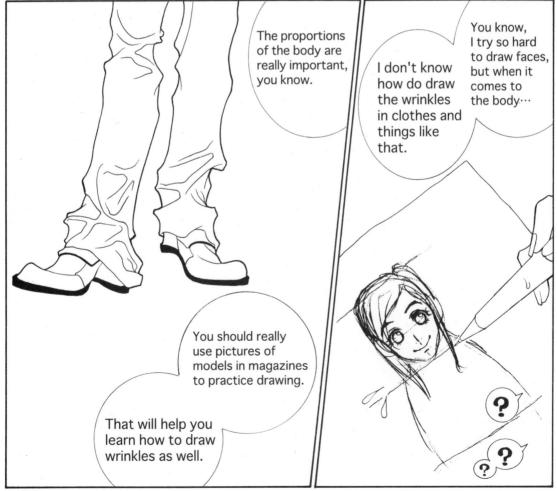

The proportions of the body are really important, you know.

You know, I try so hard to draw faces, but when it comes to the body…

I don't know how do draw the wrinkles in clothes and things like that.

You should really use pictures of models in magazines to practice drawing.

That will help you learn how to draw wrinkles as well.

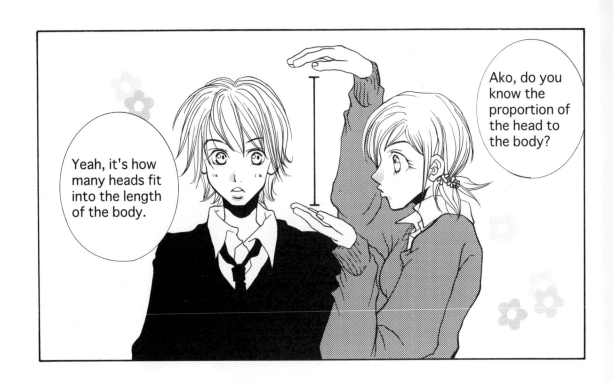

Ako, do you know the proportion of the head to the body?

Yeah, it's how many heads fit into the length of the body.

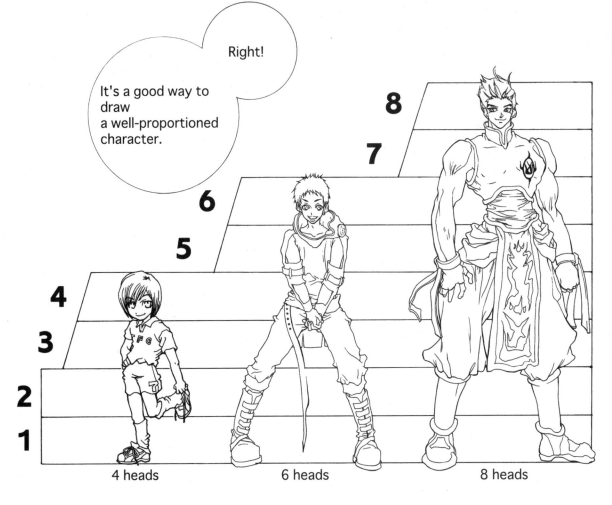

Right!

It's a good way to draw a well-proportioned character.

4 heads

6 heads

8 heads

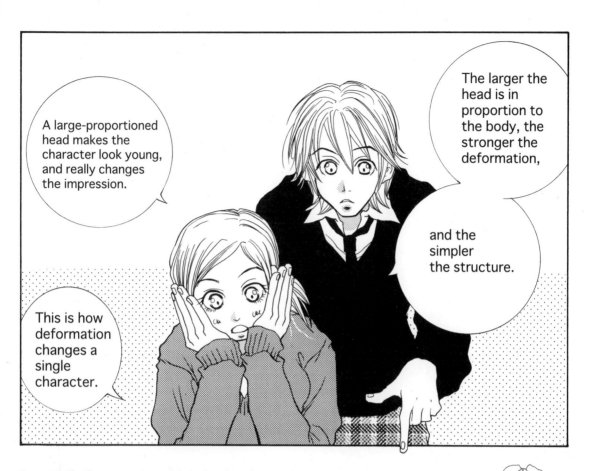

A large-proportioned head makes the character look young, and really changes the impression.

The larger the head is in proportion to the body, the stronger the deformation,

and the simpler the structure.

This is how deformation changes a single character.

For example, illustrations 1 and 2 depict characters with deformation.

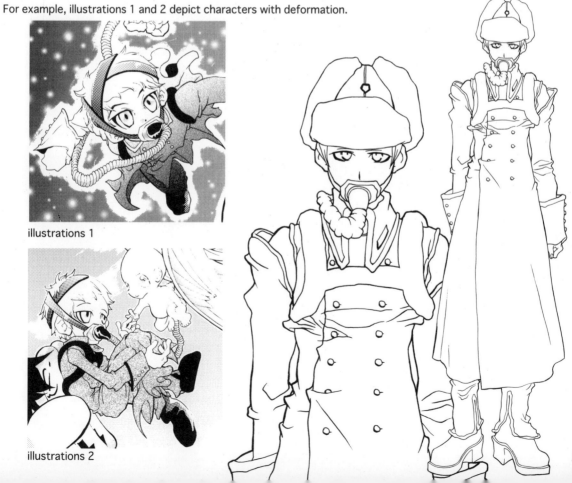

illustrations 1

illustrations 2

# Chapter 4

# Background and Perspective

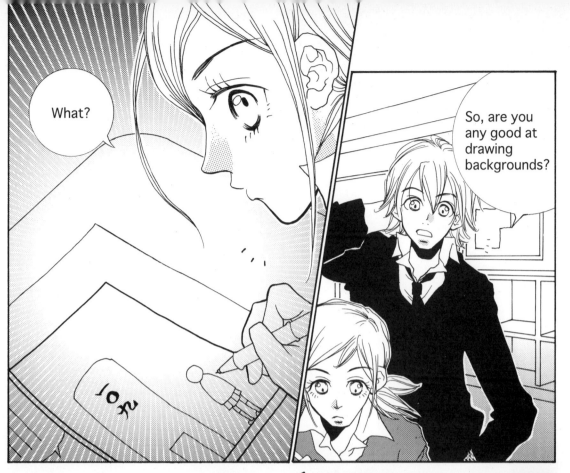

What?

So, are you any good at drawing backgrounds?

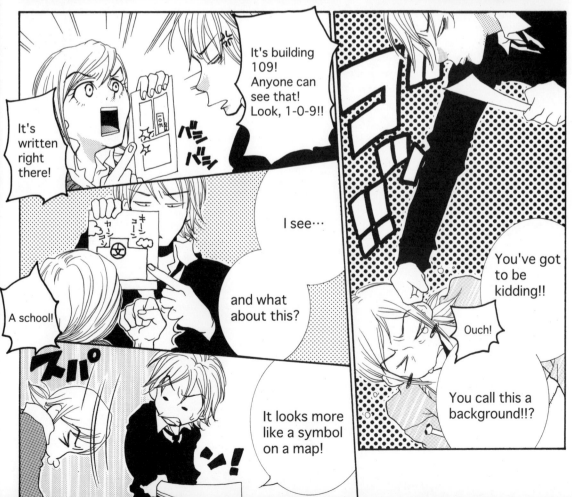

It's building 109! Anyone can see that! Look, 1-0-9!!

It's written right there!

I see…

and what about this?

A school!

It looks more like a symbol on a map!

You've got to be kidding!!

Ouch!

You call this a background!!?

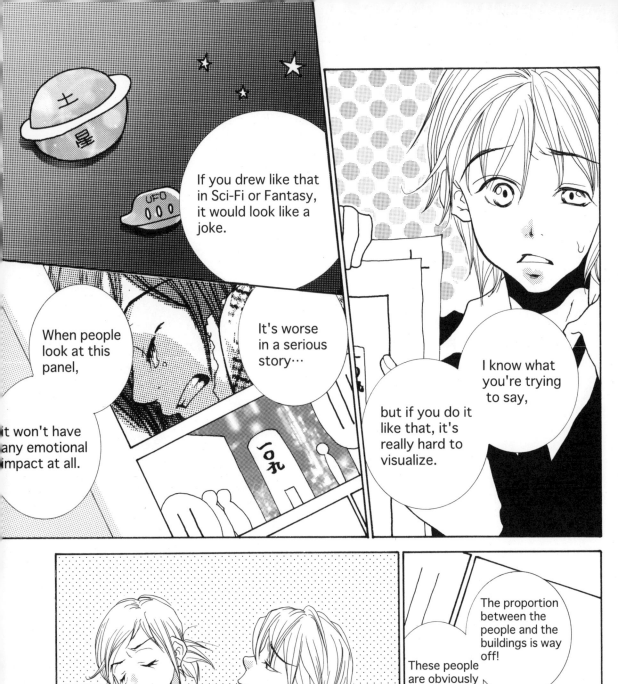

If you drew like that in Sci-Fi or Fantasy, it would look like a joke.

When people look at this panel,

It's worse in a serious story…

I know what you're trying to say,

it won't have any emotional impact at all.

but if you do it like that, it's really hard to visualize.

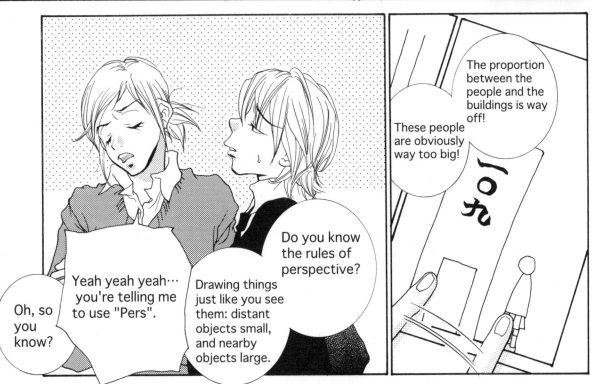

The proportion between the people and the buildings is way off!

These people are obviously way too big!

Do you know the rules of perspective?

Yeah yeah yeah… you're telling me to use "Pers".

Drawing things just like you see them: distant objects small, and nearby objects large.

Oh, so you know?

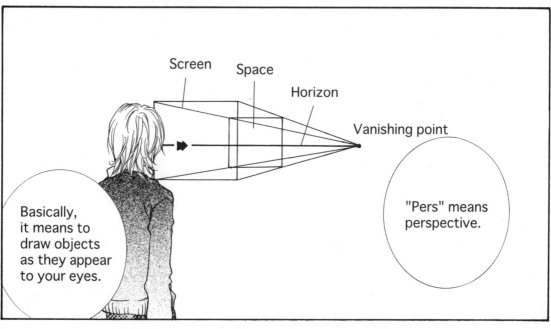
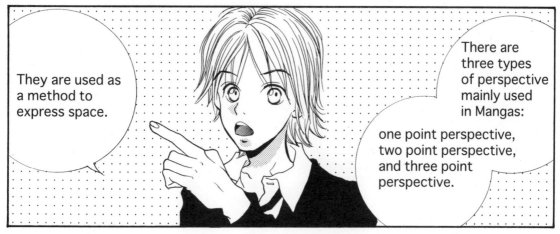

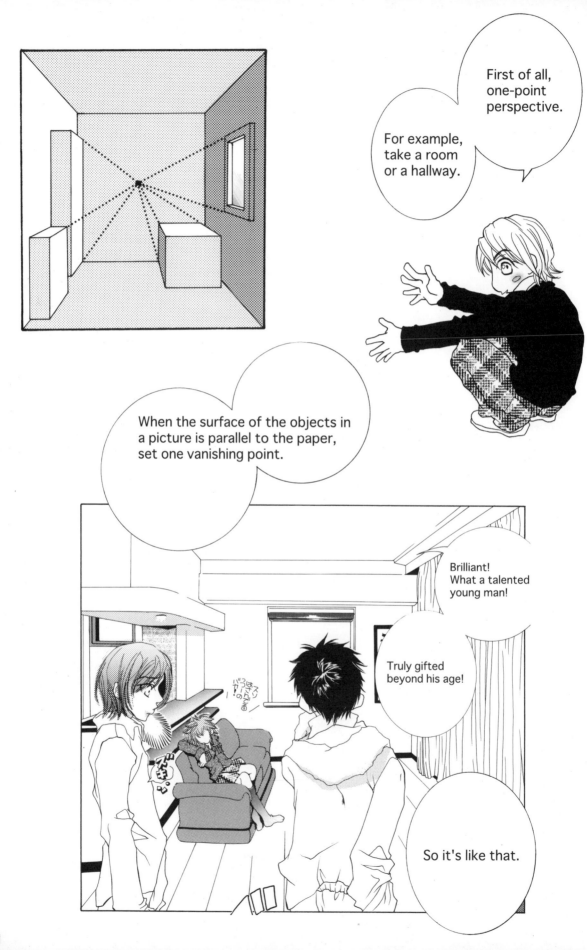

First of all, one-point perspective.

For example, take a room or a hallway.

When the surface of the objects in a picture is parallel to the paper, set one vanishing point.

Brilliant! What a talented young man!

Truly gifted beyond his age!

So it's like that.

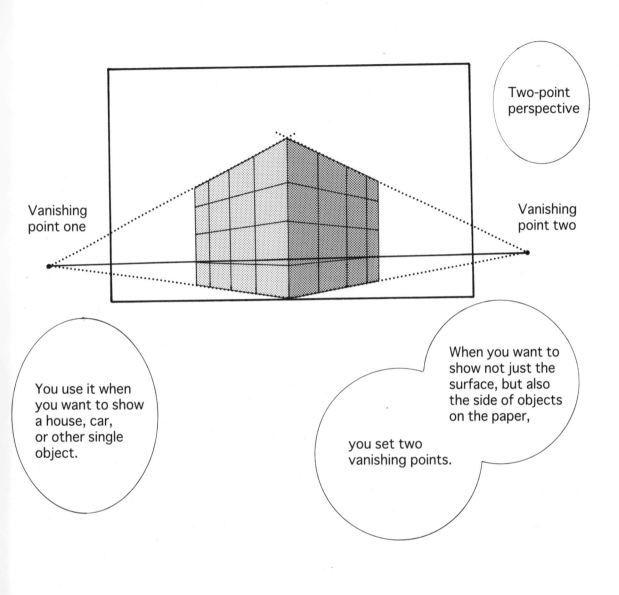

Two-point perspective

Vanishing point one

Vanishing point two

You use it when you want to show a house, car, or other single object.

When you want to show not just the surface, but also the side of objects on the paper,

you set two vanishing points.

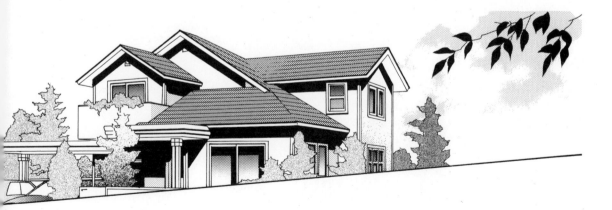

Vanishing point three

And then there's three-point perspective.

This perspective is used for places like downtown areas to express the towering height of buildings.

Vanishing point two

Vanishing point one

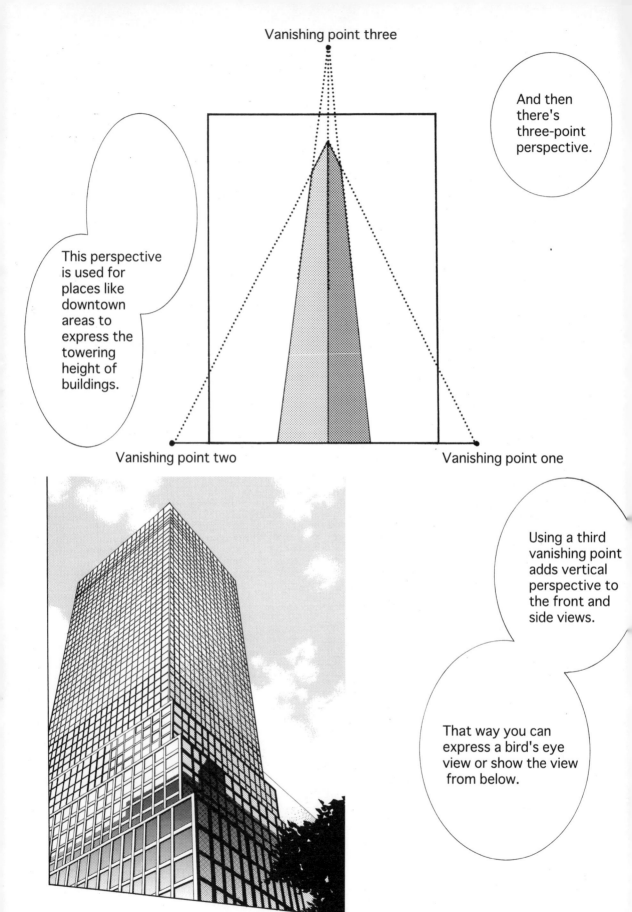

Using a third vanishing point adds vertical perspective to the front and side views.

That way you can express a bird's eye view or show the view from below.

63

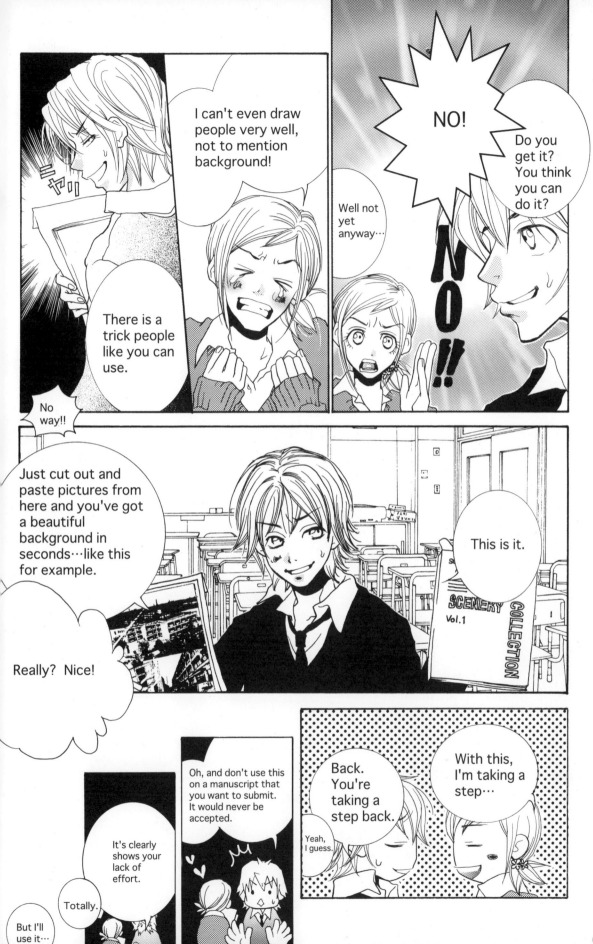

# Chapter 5

## Drawing in Panels

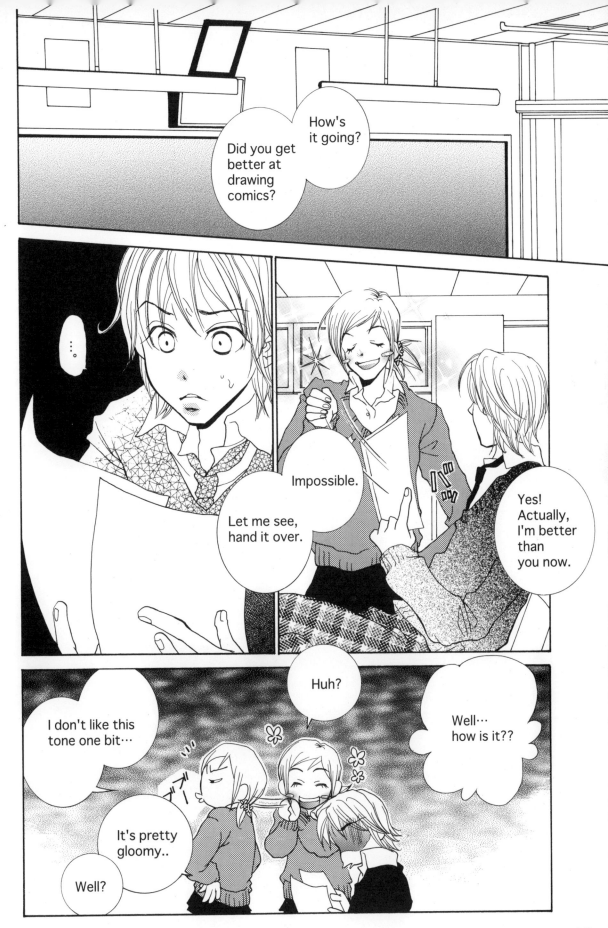

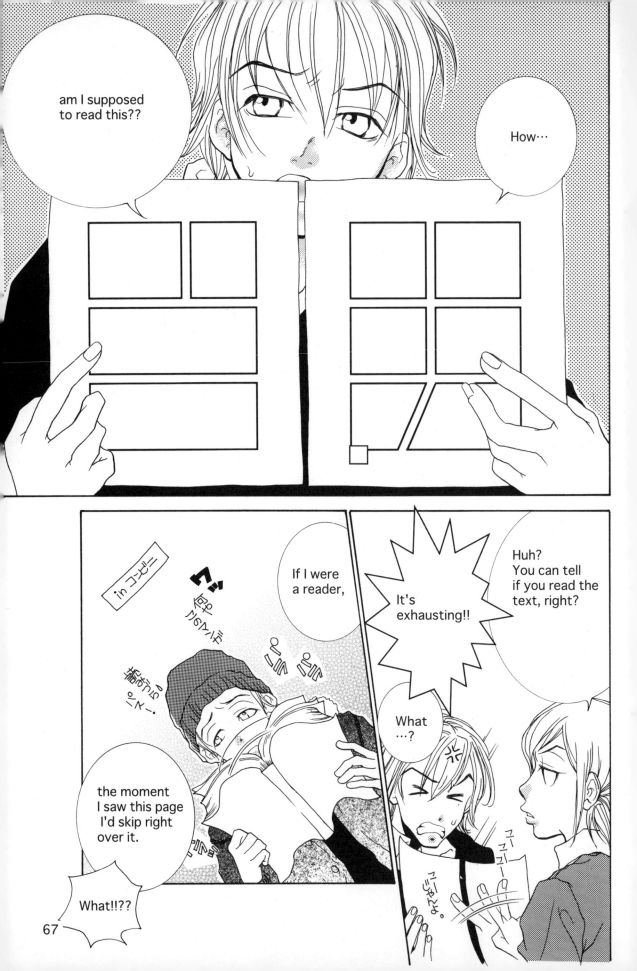

67

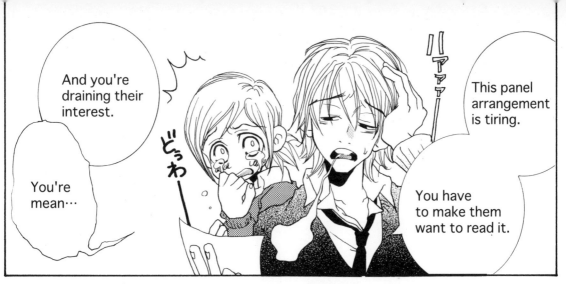

And you're draining their interest.

You're mean…

This panel arrangement is tiring.

You have to make them want to read it.

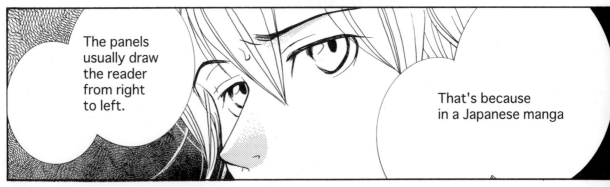

The panels usually draw the reader from right to left.

That's because in a Japanese manga

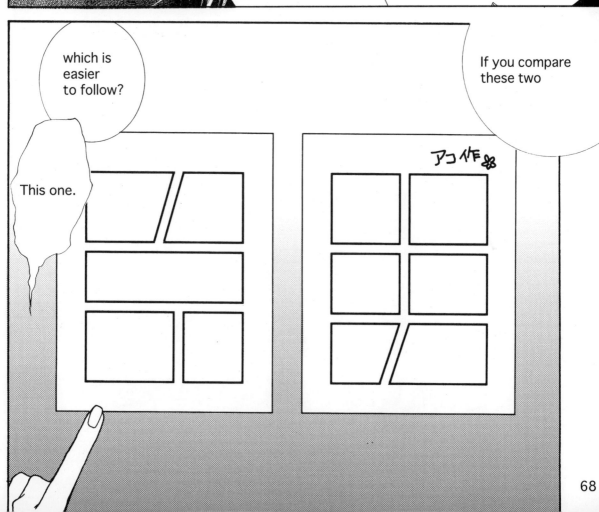

which is easier to follow?

This one.

If you compare these two

アコ作

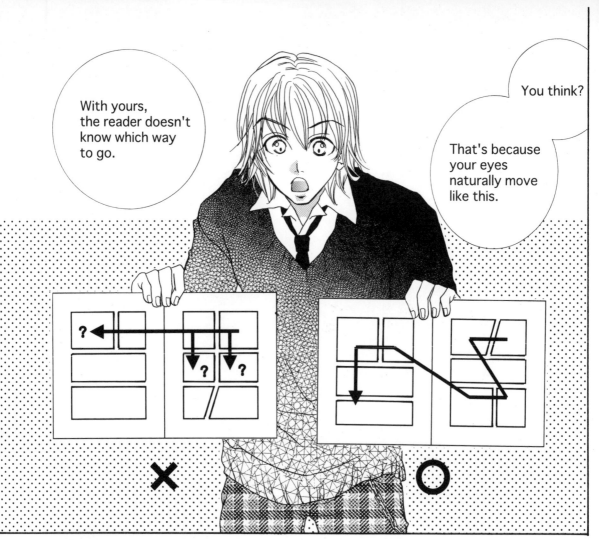

With yours, the reader doesn't know which way to go.

You think?

That's because your eyes naturally move like this.

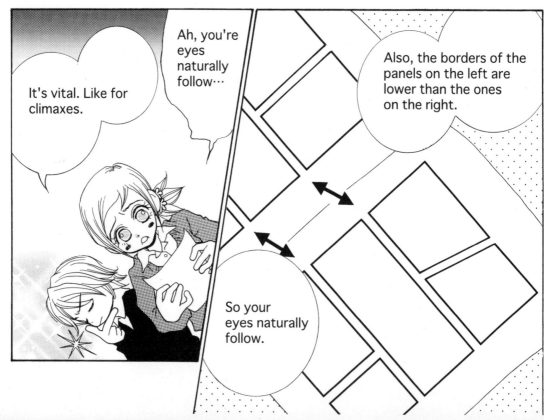

It's vital. Like for climaxes.

Ah, you're eyes naturally follow...

Also, the borders of the panels on the left are lower than the ones on the right.

So your eyes naturally follow.

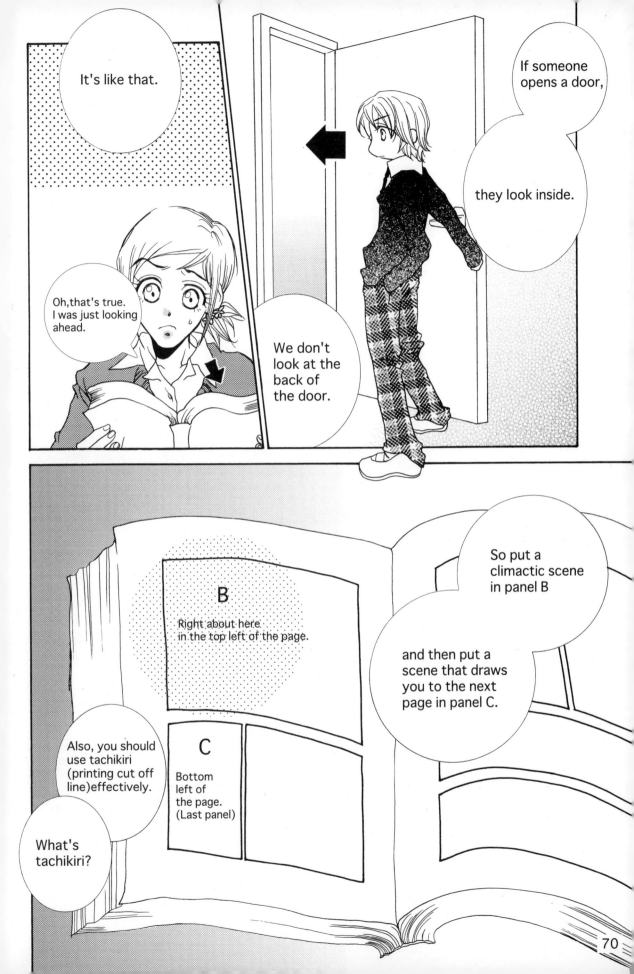

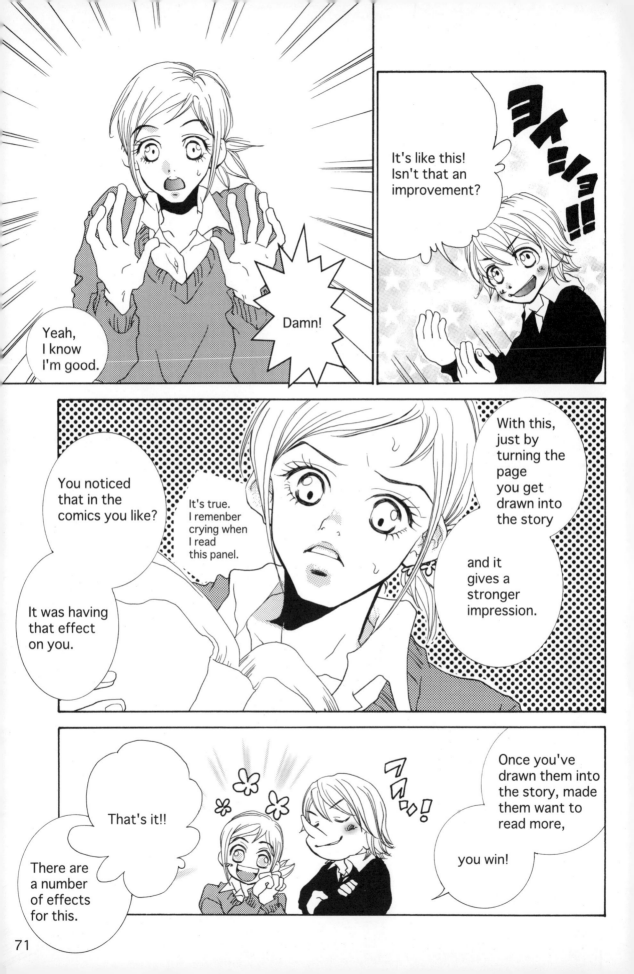

It's like this!
Isn't that an
improvement?

ヨイショ!!

Yeah,
I know
I'm good.

Damn!

With this,
just by
turning the
page
you get
drawn into
the story

You noticed
that in the
comics you like?

It's true.
I remenber
crying when
I read
this panel.

and it
gives a
stronger
impression.

It was having
that effect
on you.

That's it!!

Once you've
drawn them into
the story, made
them want to
read more,

you win!

There are
a number
of effects
for this.

71

You want to do two-page spreads?

I do, I do! They're called two-page spreads?

So tell me!

How do you go about drawing like this?

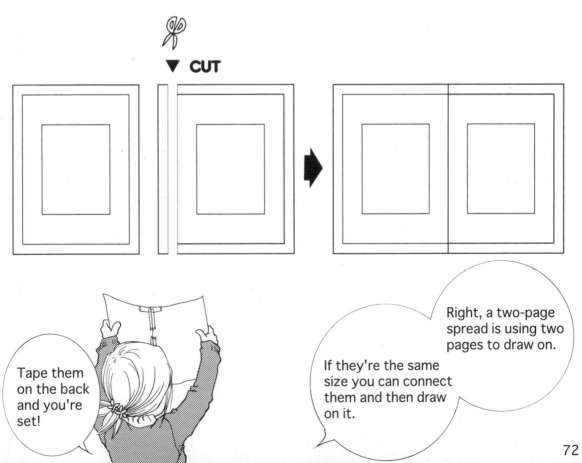

▼ CUT

Right, a two-page spread is using two pages to draw on.

If they're the same size you can connect them and then draw on it.

Tape them on the back and you're set!

The magazine is bound along the spine.

ココね

ココと

In a magazine, you usually don't draw on the spine of the page.

Wait a second, where is the spine?

But you don't even know which side of the page the spine will be on.

...Right?

Even if you drew something there, how would anyone see it?

So don't put an important picture there.

Everything I say goes in one ear and out the other!!

That's why you plan out which pages will be on the right and left when you draw a manga!!

It's a doujinshi, so I want to do it casually.

Don't you even make a rough draft first?

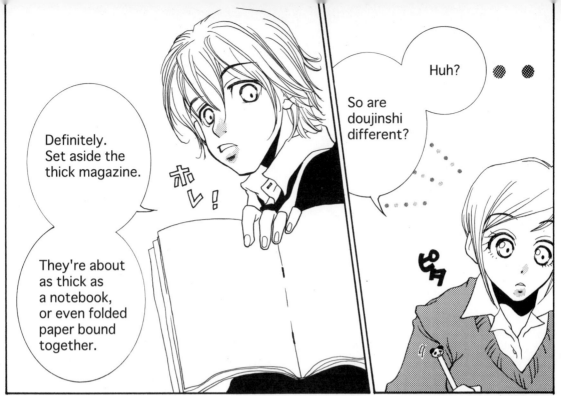

Huh?

So are doujinshi different?

Definitely. Set aside the thick magazine.

They're about as thick as a notebook, or even folded paper bound together.

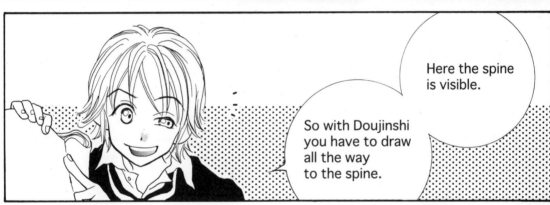

Here the spine is visible.

So with Doujinshi you have to draw all the way to the spine.

I think I did it!

You're jumping ahead. Listen to me before you start.

Wah!!!

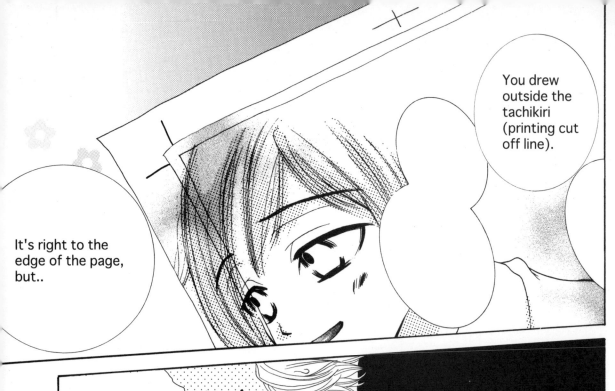

You drew outside the tachikiri (printing cut off line).

It's right to the edge of the page, but..

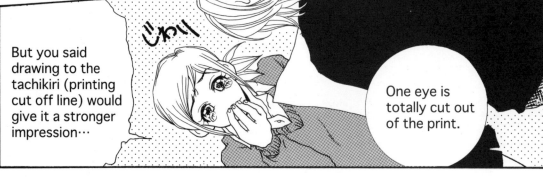

But you said drawing to the tachikiri (printing cut off line) would give it a stronger impression…

One eye is totally cut out of the print.

But I worked so hard visualizing and then drawing this face so well.

Okay, well then you have to cut and paste.

I really want to use it.

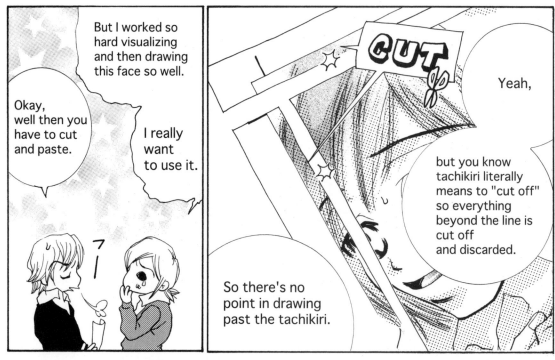

CUT

Yeah,

but you know tachikiri literally means to "cut off" so everything beyond the line is cut off and discarded.

So there's no point in drawing past the tachikiri.

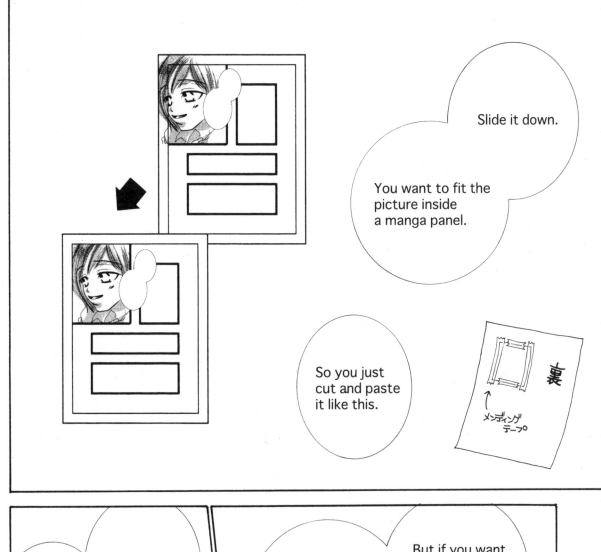

Slide it down.

You want to fit the picture inside a manga panel.

So you just cut and paste it like this.

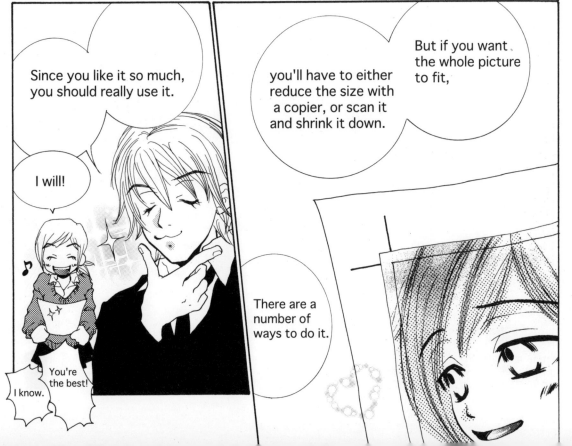

Since you like it so much, you should really use it.

I will!

But if you want the whole picture to fit,

you'll have to either reduce the size with a copier, or scan it and shrink it down.

There are a number of ways to do it.

You're the best!

I know.

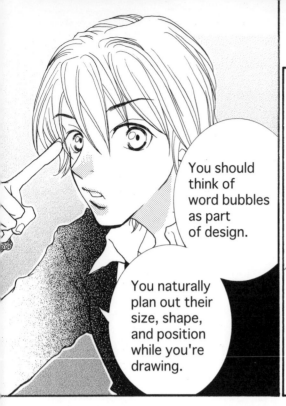

You should think of word bubbles as part of design.

You naturally plan out their size, shape, and position while you're drawing.

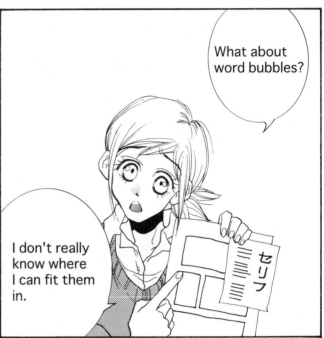

What about word bubbles?

I don't really know where I can fit them in.

セリフ

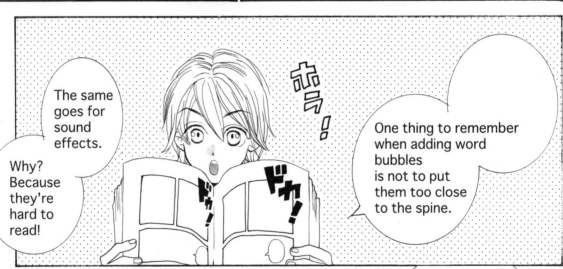

The same goes for sound effects.

Why? Because they're hard to read!

ドカ！

ドカ！

One thing to remember when adding word bubbles is not to put them too close to the spine.

Even though I'm using a Kansai accent, I'm actually not from Kansai. I'm from Okinawa

I'm from Okinawa.

Even though I'm using a Kansai accent, I'm actually not from Kansai.

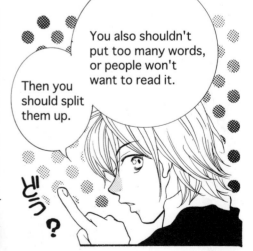

You also shouldn't put too many words, or people won't want to read it.

Then you should split them up.

ズゥ？

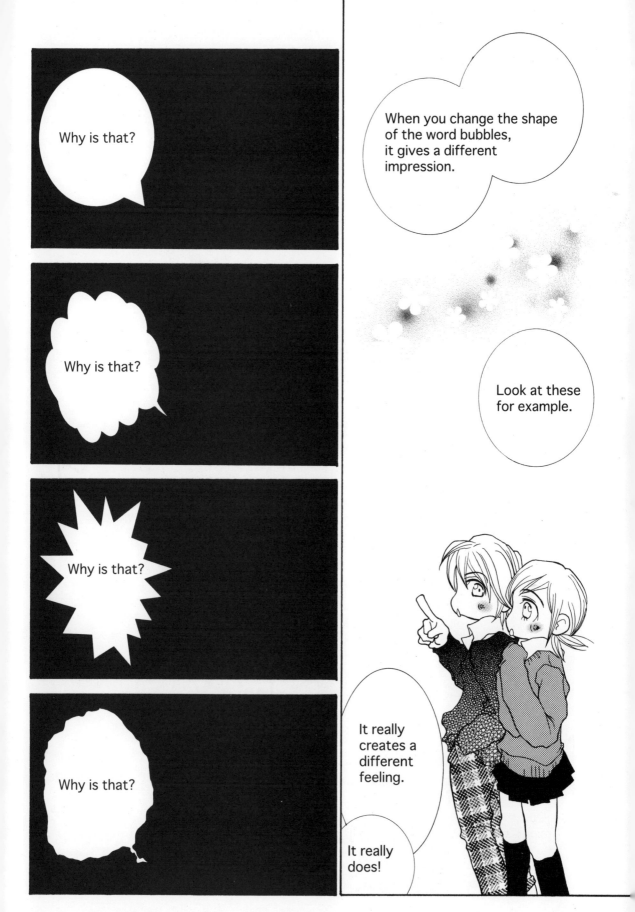

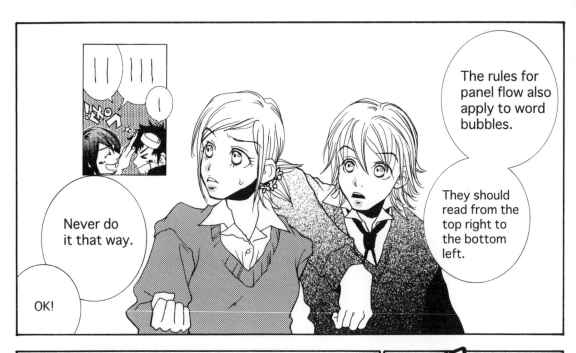

The rules for panel flow also apply to word bubbles.

They should read from the top right to the bottom left.

Never do it that way.

OK!

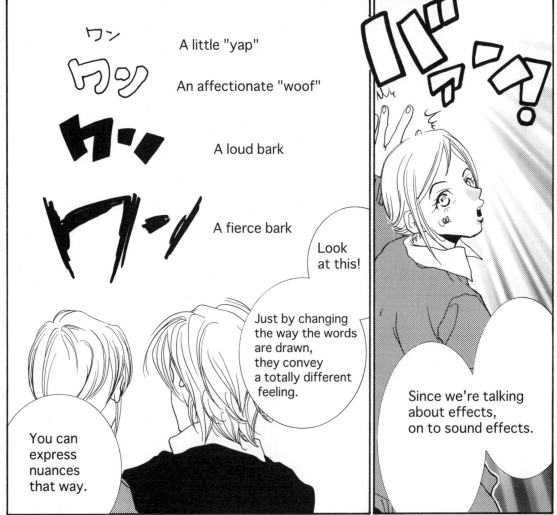

ワン
ワン
A little "yap"

An affectionate "woof"

A loud bark

A fierce bark

Look at this!

Just by changing the way the words are drawn, they convey a totally different feeling.

You can express nuances that way.

Since we're talking about effects, on to sound effects.